MW00469064

breaking boxes:

dismantling the metaphorical boxes that bind us

breaking boxes:

dismantling the metaphorical boxes that bind us

betsy pepine, MBA

ethos
collective

Published by Ethos Collective™
PO Box 43, Powell, OH 43065
EthosCollective.vip

LCCN: 2024908371
Paperback ISBN: 978-1-63680-283-1
Hardcover ISBN: 978-1-63680-284-8
e-book ISBN: 978-1-63680-285-5

Available in paperback, hardcover, e-book, and audiobook.

Any Internet addresses (websites, blogs, etc.) and telephone numbers printed in this book are offered as a resource. They are not intended in any way to be or imply an endorsement by Ethos Collective™, nor does Ethos Collective™ vouch for the content of these sites and numbers for the life of this book.

This work is non-fiction and, as such, reflects the author's memory of her experience. Many of the names and identifying characteristics of the individuals featured in this book have been changed to protect their privacy, and certain individuals are composites. Dialogue and events have been recreated; in some cases, conversations have been edited to convey their substance rather than written exactly as they occurred.

Available in paperback, hardcover, e-book, and audiobook.

For those who feel the quiet rage.
For my daughters who are doing something about it.

And for my mother and father, who gave me faith and family.

contents

prologue: scales

I was ten years old, in Ms. Turner's fourth-grade class, and I was excited to bring the new "fuzzy pencil" my grandma had just given to me to school. A fuzzy pencil is a regular pencil but, on its eraser end, has colorful fake fur hair with two small, glued-on googly eyes for a face. I loved my new pencil girl. I spent our first evening together alternating between twirling her emerald green hair into a bun and parting her hair down the middle to braid it. That night, I fell asleep with her snuggled beside me.

The next morning, she and I got ready for school, and I carefully tucked her into my book bag. On the playground, surrounded by a circle of friends, I gingerly took pencil girl out of my backpack and rolled her between my sticky palms.

Her wild hair splayed out in every direction, making her look unhinged. My friends laughed, so I did it again, and they laughed more.

"Where can I get one of these?" Billy asked me.

Like a cat spotting a mouse, my entrepreneurial spirit sprung into action. My mother had always said I came out of the womb making money, and if I wasn't making money, I was finding money. I talked Ms. Turner into turning our classroom into a Fuzzy Pencil Factory. I also submitted my name to run for class treasurer. The next day, I found out I had won.

The following week, carrying my excitement and navy blue book bag while squeezing Ms. Turner's hand until it turned crimson, I walked down the sidewalk connecting our school to Barnett Bank up the road. During my ten trips around the sun, I had never felt this alive. Christmas morning paled in comparison to the excitement I felt that day. When we got to the entrance, Ms. Turner dropped my clammy hand and opened the heavy, tinted glass door. I peeked around her to peer inside.

Although I had never set foot in a bank, I, Betsy Pepine, treasurer of Ms. Turner's Fourth-Grade Class Fuzzy Pencil Factory, was opening a bank account that afternoon. I followed Ms. Turner into an office off the bank lobby, where a young woman in a black suit smiled at me. Ms. Turner told her about our new business enterprise, and after my teacher had signed a few papers, the bank officer handed me a blue checkbook and a thin checkbook register, along with a dark brown vinyl case to put them in. I neatly tucked the checkbook and register behind the flaps inside the case and then

carefully sandwiched them between my math and language arts books in my book bag.

For the next several weeks, our class walked daily to Pic-N-Save behind our school to buy pencils, glue, fake hair, and googly eyes. I wrote the checks for the supplies and handed them to the cashier, taking great care to write and sign every pale blue check in the most elegant cursive I could muster. Before school and during recess, my classmates and I made fuzzy pencils, two dozen at a time. We quickly learned the efficiencies of an assembly line, and I became the master of winding brightly colored fake hair tightly around an eraser end.

Three weeks and two hundred fuzzy pencils later, students lined up outside our classroom door before school, after school, and at recess to buy our wares. We sold out of pencils a few times the next month and had a backlog of demand due to supply chain issues: apparently, the Pic-N-Save could not handle the sudden run on its fake fur. On Fridays, my mom would pick me up after school and take me to Barnett Bank to deposit the quarters we had collected from our sales. I coveted my position as company treasurer, meticulously recording every deposit on the checkbook register's gridlines and tracking our company's account balance.

After every kid who wanted a fuzzy pencil bought one or three, the frenzy died, and we closed up shop. Watching kids at school pay for something we had made with our own hands, catching sight of their beaming faces when they got their pencils, and seeing cold hard cash manifest out of something that weeks earlier was just an idea, were magical.

Our fourth-grade class voted on how we'd like to spend our profits.

"Let's go to the moon," Johnny suggested first.

Laughing, Ms. Turner said, "We don't have that much money."

"What about Disney World?" Stephanie said.

"It's only two hours away, but that's a bit too expensive. But... what about Busch Gardens?" Ms. Turner asked.

The class erupted in cheers, and I was elated. I'd never been to Busch Gardens before but had seen commercials of their new flume ride and could hardly wait. That afternoon, when I got home from school, I went upstairs to my bedroom, taped a piece of paper to the back of my door, and began counting down the fifteen days until our field trip with red hash marks.

Each day at school, kids from other classes came up to me and asked if it was true that The Fuzzy Pencil Factory Company was going to Busch Gardens. "Yes," I boomed each time, beaming.

The weekend before the big field trip, I was on top of the world. My family and I traveled to our home away from home—our condo on St. Augustine Beach on the Atlantic Ocean. Being away from home would make the last few days fly by before my trip to Busch Gardens. Pig-tailed and bursting with a grin, I spent the weekend in the ocean jumping and plunging over foot-high waves.

On Saturday evening, my sisters and I, along with some newfound friends staying in a nearby condo, were doing gymnastics on the lush, spacious common lawn outside the back sliding door of our unit. From this glass door, my mother called, "Betsy, we need to discuss something. Can you come inside for a minute?"

"Uh… sure, Mom," I said, knowing when my mother wanted "to talk," it was never good.

I sauntered into the condo and climbed up on one of the kitchen counter swivel stools. Mom walked across the kitchen to face me.

"Betsy," she said and leaned toward me, "I need to talk to you about your weight."

We'd never talked about my weight before. Granted, I had heard plenty of talk about other people's weight and their lifestyle choices. Why would she possibly need to talk to me about MY weight?

"I need you to know you are not fat," she said, "but if you continue eating the way you are, you will be."

My face went stone cold as I gazed into the dark brown eyes across from me. At the age of ten, I already knew there was no worse fate. I felt the walls caving in around me, like when I played Monopoly and was sent to jail without a Get Out of Jail Free card.

"Mom," I asked, almost in a whisper. "Are you telling me I am fat?"

"No," my mom said matter-of-factly. "Now, go back outside and play."

And with that, she walked away.

Still in my chair, I bit down hard on my lower lip, welcoming the pain to distract me. "Do not cry." For I was the happy child, the light-hearted one. The one that made others laugh. "Betsy, you must not cry!" I wanted to shrivel up and die. To my ten-year-old self, that option could not be worse than being fat. I stuffed my trembling emotions away, feeling a low so painful I didn't know how to process it.

What I did know, at ten years old, was that my life as I knew it was over. My innocence escaped through the open back door of our beach condo that evening, never to return.

I had experienced my first D-Day—a line had been invisibly drawn delineating my life before and my life after this revelation. Nothing was worse than my mother telling me I was fat. I recalled the snickering comments about overweight people I had heard. "Lazy," "gross," "out of control," and "unhealthy"—all said with disdain. The message I had gotten in my first decade of life was that being fat was an area marked off by the bright yellow "CAUTION—DO NOT ENTER" tape pulled tightly across a crime scene. Do not, under any circumstances, cross this line or else... or else, something terrible will happen.

On D-Day, I learned self-hate, decades before I learned self-love. At that moment, the umbilical cord connecting my mom and me was severed for a second time. I felt untethered, floating up into the dark evening sky all alone, like a helium balloon long after its release, searching for its new home.

Unlike the childlike wonder I experienced on my first trip to Disney World two years before, my newfound self-consciousness about my body marred my ability to enjoy Busch Gardens. On the newly opened Skyride taking us from Crown Colony to Stanleyville, I worried if my thighs touched when I walked and vowed to alter my gait if, when I got off the ride, I found out they did. All I could think about as I stepped into the seat of the boat to experience the thrill of the 43-foot drop on the Stanley Falls Flume was whether I could get the ice cream cone we were promised after lunch or if Ms. Turner would skip me because I was now fat. At ten, for the first time, I felt shame, not for something I had done but for who I was.

Recently, I was going through pictures in old photo albums my mother made for me. The book that covered the field trip displayed a faded Polaroid photo of me and my best friend Suzy, arm in arm, smiling broadly at a camera being held by my mother, a chaperone on the trip. I had the giant brown bear stuffed animal I had just won on the midway playing a carnival game. Lifting the yellowed plastic sheet covering the photo page, I peeled the picture off the paper. I tore the picture into pieces and flushed the pieces down the toilet, no longer wanting a reminder of that distressing day, the day I first plastered a smile on my face to mask the pain inside.

part one: boxed in

boxes

As a real estate broker, I see boxes every day. Buyers and sellers use them to neatly pack up their lives and haul them across the street, the city, the country, or the ocean. Boxes can be quite useful and have their place—temporary storage to keep things safe, out of harm's way. But I have also witnessed other kinds of boxes—boxes that are invisible, are persistent, and when our consciousness expands, we see they are sinister. Still, other boxes (ones I try to avoid) are more obviously treacherous, but somehow, I find myself back inside them from time to time.

These invisible yet confining boxes are constructed of expectations and opinions—our own, other people's, and institutions—of us and of the various roles we perform in society. The gender box, the good girl box, the dutiful wife box, the "this is what we do in our family" box, the career box, the religious box, the ethnicity box, and so on. Subconsciously,

one can morph into a communal amalgamation of self, a self that adheres to the expectations of the people and communities in which we live, unaware we are losing our very selves in the process.

One of my earliest and strongest memories is something I did often in middle school. At twelve years old, I would diagonally sprawl across my bed, lying face up on my full-sized flowered bedspread in my bedroom upstairs. Usually in the middle of the day, in a hot Florida summer. It was silent in the house, and I wasn't sure where my sisters or mom were. I would go through an exercise I called "Who am I?"

"Who am I?" I'd whisper into the silence. I'd wait and hear nothing. "Who am I really?" I'd ask the silence again. "Who is this thing people call 'Betsy'?" Next, I'd bring my leg up and reach for my foot, touch it, and say, "If I didn't have this foot, who am I? Am I still 'Betsy'?" I'd move my hand up my right leg. "What if I didn't have this leg or my foot? Am I still 'Betsy'?" I'd move my hand up to my arm. "What if I didn't have my arms too? Who, then, would I be?" I was fairly convinced I'd still be the "me" trapped inside this body I was touching, but who was that really? Each time I did this exercise, I concluded the "I," what makes me *me*, cannot be my body because I knew for sure that "I" would still be there even if I lost my physical body parts. "I" was not my body, nor did "I" reside in my body.

As I grew older, I'd run through this exercise but with various thoughts and feelings. If I didn't have this thought, would I still be me? Yes. What about this feeling? If I didn't have it, would I still be me? Yes, again. I concluded: "I" was also not my thoughts, nor was "I" my feelings.

This was where the exercise stopped because often, I could no longer breathe. I felt stuck—in a box taped so tight I could not escape. My younger self could not reconcile if I

was not my body, my thoughts, or my feelings, then why was I, the real "me," constantly being judged by what my body has, does, thinks, or feels?

Physical boxes, by their very nature, are designed to be temporary. We forget boxes have thin walls and are meant to be broken down, flattened, and taken to the curb on garbage pickup day. Invisible boxes can also have a transitory quality, but too often, we hunker down and nest in these boxes, afraid to leave the known for the freedom found beyond. The longer we stay, the easier it is to forget we are living in one until one day, we realize we are Jim Carrey in *The Truman Show*, thinking we are living an ordinary life, oblivious to the fact it's being played out on a set orchestrated by others.

In my home office, beside my computer, is a picture of a young girl. She looks to be about the age of four. She is in a one-piece bathing suit, her legs splayed out and nestled in lush green grass. Rain is pouring down on her head, and her face is radiating pure, unbridled joy. I have this same picture at my office at work, on my computer, and on my cellphone as a screensaver. I'm not sure where I first saw this picture. The internet, maybe. But the minute I saw it, I got goosebumps. I couldn't get the girl out of my mind. Especially the words spread across her waist in the photo: "REMEMBER HER?" And lower, across her shins: "She is still there... inside you... waiting... let's go get her." For some inexplicable reason, I felt compelled to keep that picture all around me.

One summer, in my late forties, I was feeling increasingly unsettled. For months, maybe longer, I had been restless, unhappy, slowly filling with rage that I could not rationally explain. How can this be? I had everything I wanted. Wonderful kids and rescue pups, several thriving debt-free businesses, a spacious and beautiful home, and a boyfriend

who was a surgeon. Maybe I was just feeling out of sorts because my girls were headed off to college.

In August of that summer, a hurricane was predicted to hit the south, and my state of Florida braced for it. After filling up the car with gas and buying sandbags, batteries, and bottled water, my pups and I hunkered down. The power went out within the first few hours, and I lit candles as the sun set. Anticipating this, I pulled out the project I had planned in the event of loss of power and carried three shoe boxes full of photos to my kitchen counter. My goal was to give these photos a final resting place in albums I had bought years before.

Sitting on the kitchen counter stool, I began going through the photos, throwing out ones that were out of focus and sorting the keepers roughly by age. Two hours later, I had made my way through the boxes. I walked the empty three boxes to the trash can and saw at the bottom of the last one, a lone photo with its white backside facing up. I reached in and picked it up, a candle flickering nearby. I turned the photo over and moved it closer to the candle. Faded, it was a photograph of a small child in her favorite red-striped one-piece bathing suit, looking straight into the camera. I was standing a few feet in the ocean water, plunging toward an oncoming wave as if to try to hug it. My father stood three feet in front of me, beautifully capturing the water droplets suspended in air, framing my wide grin and the pure innocence radiating from a child in wonder. At the bottom right of the picture, in my mother's handwriting, read "Betsy, age 4."

Jolted, I felt hit with a bolt of lightning. But this lightning wasn't coming from the storm outside. Holding the photo, I grabbed the candle in its glass jar and ran down the hallway towards my home office. I went to my computer

and held up the candle to the picture on the wall beside it. The picture of the girl on the lawn, in her one-piece bathing suit. With the rain coming down on her head. With her face radiating pure, unbridled joy. This image, the one I had felt compelled to surround myself with years prior. I looked back at the photo I was holding. My four-year-old self was looking directly at me. *REMEMBER HER? She is still there... inside you... waiting... let's go get her.*

While the hurricane passed in two days, the brewing inside me grew, and I began a journey of self-discovery through reading, meditation, going through past journals, and reflecting on when and how I lost myself. One theme that continually surfaced was feeling put into a box, a box I often was not equipped to recognize or, if I did, I ignored that it was not supportive or it had lost its value. This book shares stories of how I navigated the ins and outs of the boxes encountered in my life and how I found my way back to that four-year-old self.

privilege

I am white. I look white, and I live in a country that places value on lighter skin tones. I was born into a family with financial means, so I never worried if the heat was going to be on or where my next meal was coming from. I had my own bedroom, I played sports, and I got a new outfit for the first day of school every August. Generation upon generation valued education, and there were expectations and accountability. I won the family jackpot and am grateful every day for it.

When I started my career in real estate, I was accepted into *Leadership Gainesville*, a year-long program for leaders to learn more about what it takes to run a community and improve their leadership skills. The class met one day a month for a year. Not knowing what to expect, I arrived, full of excitement, at the Chamber of Commerce on the first day. A facilitator started the session and told us we would be

doing an all-day simulation called SIMSOC, creating and running our own community.

The facilitator handed me a blue shirt and told me to change into it. Back in the classroom, I saw fellow participants gathered by color—green, yellow, blue, and red. I found Team Blue. They led us into a small, windowless room with seven uncomfortable hard chairs, and we were each given a 36-page participant manual of rules and activities. Seven of us took a chair while the last person took a seat on the floor. I thought it was odd they didn't have enough chairs for all of us, but we had been instructed not to leave the room before we read the manual, so we couldn't request another chair.

We would create our own community and, through four rounds of play with the other groups, we would work together to complete our assignments while confronting issues like diversity, trust, leadership, use of power, and justice. However, each group was sequestered, only able to interact with another group by obtaining travel passes held by select players who owned travel agencies. Upon completion of each round, each person in a group had to have enough food to survive (measured in subsistence tickets held by select players or in luxury living passes that could be purchased at the SIMSOC bank) for the next round. While there were no winners or losers, the manual explained some groups would do better than others in achieving the goal of utilizing social processes like cooperation, reward, threat, and punishment to better understand social and organizational theory.

The simulation was confusing initially, but after the first round, our team understood the basics and began building a strategy to achieve the stated goals. Communicating with the other teams was cumbersome, and making sure everyone

in our group had a meal ticket was challenging, but we made it through to Round 2. Equally hard, the blue team became frustrated when we couldn't earn a travel pass to communicate with other regions (color groups) and had to rely on them coming to us. (Travel passes were given initially to some members of the other teams and could also be purchased if you had enough money to buy them.)

After Round 2, we were famished, and someone delivered us lunch—a brown paper bag with a peanut butter sandwich on white bread, half an apple, and a small bottle of water. I was perplexed. This was a class filled with community leaders, I had paid $1,000 to participate, and this was lunch?

By the middle of Round 3, our group's circumstances and the simulation maddened me. The organizers wouldn't even give us an extra chair so we could all sit down. We didn't earn enough money to travel consistently to the other groups to make deals and had to passively wait and hope that someone would come to help us or, at a minimum, tell us what was going on.

After Round 4, we met in the main room to debrief. We sat with our groups, clearly wanting to be segregated and show solidarity to our respective teams. The blue team was in a foul mood by this time, but when we entered the room, the green team was filled with laughter and smiles. In the debrief, we learned that the groups represented socioeconomic classes, and Green was the richest. Their room had plush sofas and tables to sit at, and they had a catered lunch brought in. They started out with the most food tickets and travel passes. The yellow team was the second richest, with fewer amenities than Green. Blue was next, and Red represented the poorest region. Their chairless room was smaller than ours, and they spent the day sitting on the floor and eating half a sandwich for lunch.

While I forgot many of the details of that day, what I will never forget was how I felt. I wanted to scream. I questioned whether I wanted to continue in this leadership group. The way we were treated felt so unjust. Why were others lucky enough to get a green shirt when I was handed a blue one? My fate was sealed by happenstance. Lamenting this as I walked to my car, I passed a business with an eagle on its signage—an eagle, our nation's symbol of freedom. How free are we really? I just spent eight hours living in a simulation that I walked out of and returned to my normal life while others had to live on Team Red every day.

While writing this book, I struggled with whether being in the privileged box excluded me from writing. What right did I have to write about changes I'd like to see in a world where I had it better than most? However, I do know we all have something to share. I've learned from an array of folks, many of whom drew the short straw on privilege but busted out of boxes bigger than any I'll ever encounter. It is my hope that everyone, from the green team to the red team, walks away learning something new or having a different perspective as a result of these stories.

naps

It was 1972, and I was four years old. My mom had decided my twin sister, Anne, and I needed to go to nursery school. She'd selected a private Christian school in Cherry Hill, New Jersey, and today was the first day. A ball of energy, I was thrilled to be going somewhere new and meeting other kids. My sister and I excitedly took turns standing by the kitchen counter in our beautiful homemade dresses. Her hair was already done, and now it was my turn. My mom parted my hair down the middle with the pointy end of her thin black comb and pulled half my hair up on each side into high pigtails.

My favorite part of my first days was skipping in the aisles of the auditorium or around the maypole outside. Oh, how I loved to skip, my high pigtails swaying side to side as I moved and my heart racing happily to keep up. After a few hours, it was nap time. Mats were rolled out onto our

classroom floor, and we each found one to lie on. I picked a robin's egg blue mat and laid the towel my mom had sent with me over it. At four years old, I liked having my own mat. It reminded me of being at the beach when I laid out my beach towel, staking out my own space in the sand. This was my space, and my sisters were forbidden to come onto it.

With my towel down on my mat, I happily laid down on my stomach, just like I did at home. My twin sister was close by, lying on the mat beside me, so I could see her until I fell asleep. The teacher told everyone to be quiet until she turned the lights back on, signaling nap time was over. We had thirty minutes to rest. Never having trouble falling asleep, I was dreaming of the fireflies I had caught the night before, minutes after lights out.

One day, after skipping around the maypole, it was nap time again, and my sister was lying beside me as always. Halfway through our rest period, I was jolted from my slumber by a tug on my pants. I whipped my head back to see what was happening and saw a boy in my class standing over me, and my new pink cotton panties, checkered with hearts, were staring back at me. The other kids started to laugh. Instinctively, I tugged up my pants as my armpits released beads of sweat, and tears pooled in my eyes. My teacher came over and asked what happened. Stammering, I pointed to the boy who had caused the incident. She went over and talked to him in words too soft for me to hear while I tried unsuccessfully to return my fallen pigtails to their home high on my head.

The next day, it happened again. On day three, I refused to sleep during nap time. Instead, I laid face up on my back, eyes wide open in terror, my hands pulling down hard on my high pigtails to make me feel less visible. I repeatedly counted numbers from one to 100 in my head until the lights were back on. I never took another nap at that school.

According to the school's website, it's dedicated to providing a safe, loving, and nurturing environment for children eighteen months to five years old. At four years old, I didn't understand gender-based violence. What I did understand was I was not safe.

closets

One afternoon in 1974, my mom found my twin sister and me playing in the walk-in closet of our pink bedroom. One of us was trying to kiss the other on the lips. I don't remember who was doing what, but I do remember my mother opening the door and yelling for us to stop. She asked us what we were doing, and we told her. The next day, my mother piled us into the back of our wood-paneled station wagon and hauled us off to see the pediatrician. She apparently feared we might be gay. After a short discussion with Dr. Andersen, he assured my mom our play was normal for six-year-olds and was not a precursor to homosexuality. She needn't worry.

With a mere six revolutions around the sun, I didn't understand much about being gay, but I was acutely aware that being gay and having my mother's love were mutually exclusive. I felt ashamed that I had jeopardized my mother's love and acceptance, and I sure as heck was not going to do that again.

turkeys

I was eight years old, in second grade in Mrs. Blair's classroom at the end of the elementary school's middle corridor. Thanksgiving was in two weeks and Mrs. Blair was about to announce the winner of the turkey coloring contest. She had given us a crisp white sheet of paper the week prior with an outline of a big turkey in the center. I carefully took it home and stared at that turkey for days, afraid I was going to make a mistake when I started coloring it.

I spent hours laboring over my 12-count Crayola crayon box, trying to decide what colors to put where, figuring out how to mix colors to make burnt red and bronze-green for the wattle and feathers. I practiced on a scrap sheet of paper how to shade lighter in some areas and darker in others. Finally, with shards of crayon scattered over the placemat in front of me and the waxy smell of crayons permeating the jumper I was wearing, I felt confident I was ready and started

coloring. The next day, the Friday before Thanksgiving, I turned in my masterpiece.

Now, sitting nervously in my classroom with Mrs. Blair at the front of the class, I heard my teacher say, "And the winner is… drumroll, please… Betsy!"

I let out a squeal. This was the first time I had won anything in my life. Mrs. Blair held up a gold sticker for me, and I ran to the front of the class to claim my prize. She placed the sticker on my shirt and held up my colored turkey picture for the class to see.

Stephanie, a classmate who sat two rows to my left, raised her hand. Mrs. Blair saw her and called on her. Stephanie spoke softly. "Mrs. Blair, I was just wondering… uh… why did Betsy win the contest?" Mrs. Blair smiled broadly and, without hesitation, said, "Look how well Betsy stayed within the lines." I beamed with pride at my teacher's compliment.

By eight, I had mastered staying within the lines. Before I started coloring any picture, I took a crayon and, bearing down hard, meticulously outlined each section of the picture, creating a thick, raised waxed line separating each section of color. Then I'd go back in with the desired color of crayon and lightly run the crayon back and forth until I felt the waxed line marking the boundary over which I would not cross.

My propensity to stay within the lines plagued me for years, with me choosing what I thought I was supposed to do, be, or think over what I really wanted. Staying within the lines may earn us stars when we are eight but can cost us our souls when we are forty-eight.

skates

I got roller skates for Christmas the year I turned twelve. The real kind of roller skates. Not the silver metal ones with thick, red, hard plastic bands to hold your feet in place and a key on a thin rope that hung around your neck. Nope, that year, the lace-up ones with four rubber wheels and a big knob at the front to break a fall took up residence under our tree.

On a hot afternoon that summer, I skated to Eckerd Pharmacy, the drugstore in a strip mall about half a mile from my house, to check out their huge assortment of makeup in every shade and formulation imaginable. Mom had recently laid out the house rules for makeup. In sixth grade, we could wear eye shadow; in seventh grade, we could add blush; and in eighth grade, mascara. I was prepared to spend my hard-earned allowance on my first eye shadow purchase.

Off I went, happily skating to Eckerd's. Despite wearing my favorite shiny, light blue Dolphin satin running shorts and a tank top, I was sweating fifteen minutes later when I arrived at Eckerd's front door. It now dawned on me I had no shoes to put on to walk into the store, and I wondered for a hot minute if this would be a problem. Deciding it was not, I opened the store door and glided in, making my way to the makeup area located on the far right side of the store. Getting there, I saw the side wall was entirely mirrored and covered with hooks that held a glorious array of makeup. I stood facing this mirrored wall, first looking at myself in the mirror and then taking in all the colorful packages of blush staring back at me.

I suddenly felt a hard pressure between my thighs. I froze, not understanding what I was feeling or what was causing this pressure. I lifted my head, and in the reflection of the mirrored wall in front of me, I saw a tall, sandy, brown-haired man standing behind me. He had pressed the tips of his fingers between my thighs, cupping my vagina from behind, and was pushing up on it. My mouth dropped open to scream, but nothing came out. My instincts told me to run, but when I turned to bolt, I remembered I was on skates and lost my balance and stumbled. When I looked up again, the sandy brown-haired man was running out of Eckerd's.

Terrified yet angry, I regained my balance and skated to the other side of the store to find a cashier. By the time I reached someone, the man was long gone. I told the cashier what had happened but left wondering if she believed me, as she seemed more interested in admonishing me for wearing skates in the store than reporting the sexual assault to the authorities.

I left the store and skated home as fast as I could. After I told my mom what had happened, she called the police, and two officers arrived on our porch twenty minutes later. My mom invited them in, and we stood in the kitchen in front of our round white breakfast table. One officer asked me what the suspect's approximate age was. I told him I had no idea, that I had only gotten a quick glance at him. I didn't see any gray hair, but other than that, I was not sure. The police officer told me to just guess. I really had no idea, but I felt pressured to answer, afraid to say the wrong thing. The only adult man whose age I knew for sure was my dad, who was thirty-nine. He had gray hair and this man hadn't.

"Uh, thirty?" I guessed. The officer smiled and asked me how old I thought he was. Again, I told him I had no idea. He told me to guess anyway.

"Twenty-five?" I said, not wanting to offend him.

He laughed again and said, "You really aren't good at telling someone's age, are you?"

"No, I told you that when you first asked me," I wanted to retort, but instead, I stayed quiet because he was a police officer in uniform with a badge, and I was only twelve. He laughed again and turned around to leave. That was the last time I heard from him or discussed the incident with anyone.

Long after, I questioned why I didn't scream when it was happening. Why did I freeze? Maybe if I hadn't, the sexual predator would have been caught. The incident reminded me of nursery school, where my classmate had enjoyed pulling down my pants at naptime. At twelve, I understood both the helpless feeling of being violated and the hopeless feeling of not knowing what to do about it.

The experience confused me. Life went on as normal for everyone else, but I was left questioning how I could feel safe in a world where there were no consequences for stepping outside our country's legal box of laws written to protect its citizens residing inside.

oak room

Shortly after "the fat talk" with my mother, a scale mysteriously appeared in the upstairs bathroom my sisters and I shared. I started weighing myself multiple times a day. Twenty-four hours did not go by without me asking my mom, "Am I fat?" Throughout elementary and middle school, my mom controlled our food by plating our meals. I only noticed this was unusual when I started to go to friends' homes for dinner, and their meals were served "family-style," where large serving platters and bowls were filled with food and laid out on the table to share, and you served yourself. What freedom! In our home, my mom always portioned each item on our plates and set the plates on the counter, where we took them to our place at the table. She also prepared our breakfasts and packed our lunches. In high school, this created a problem for me because the school had kiosks that sold enticing junk food

to students. Some days, I would bring quarters to call my mom from the pay phone and ask if I could get ice cream. I was not calling her for permission to spend money on ice cream; I was calling to ask if she thought my weight could bear me eating ice cream.

Preparing to go to college, I had anxiety about being able to maintain my weight. I had heard of gaining the dreaded "Freshman 15" and wanted nothing to do with that. However, in my first year, I proceeded to gain those pounds, enticed by the continuous availability of unhealthy food and being able to make my own choices.

Despite this, I loved college but dreaded the breaks. When I went home, my parents would opine whether I had gained or lost weight since they had last seen me. My grandparents, too, would comment. This baffled me because outside of gaining and then losing the "Freshman 15," my weight never fluctuated by more than a size. But I was filled with shame every time my weight was the topic of conversation. During this time, when I had a doctor's appointment, I would step on the scale backward, facing outwards toward the nurse. She was weighing my value, and I could not bear to look.

In addition to going home during breaks, I also dreaded returning to campus. For pocket money, I waitressed at a university-owned sit-down restaurant—the Oak Room on the Duke University campus. Students could use their Duke Food points here, and the restaurant always had a line out the door with students wanting a nice meal. The Oak Room was run by a woman named Sue, who was the spitting image of Mrs. Piggle-Wiggle, the main character of one of my favorite childhood books. Ms. Sue ran the

restaurant like a ship's captain and had a loyal staff that came back year after year.

Returning every August and January to campus after breaks, I'd climb the stairs to the Oak Room entrance to start my first shift, bracing myself for what was about to come. Ms. Sue would be standing behind the cash register, come out from behind it and say, "Let me get a good look at you." She'd shift her gaze from my head to my toes and then back up to my eyes.

"Looks like we gained a few pounds this summer, eh?" Every time.

I would smile back at her, mumble something, and walk toward the kitchen, relieved this ritual was over until the next break. My shame bucket overflowed, and I felt worthless in a world preoccupied with my weight. I knew that I needed to get out of this box.

baby

I was the third and last child in my family. I have a sister two years older and a sister thirty-two minutes older. Even though I am a twin, I consider myself the baby of the family. Delivery rooms label the first-born twin, Twin A, and the second, Twin B. Our real names, Anne and Betsy, conveniently matched their naming convention, and since that day, I was unofficially deemed the baby of the family. For our meals, my family gathered for breakfast and lunch around a circular white melamine kitchen table, with assigned seating, always in birth order. My mother signed cards from the family in birth order and still puts our names in birth order on group emails and texts to us.

Alfred Adler, in the early 1900s, suggested birth order affects personality. The theory is that each birth order position has a personality disposition. Firstborns are known to be more controlling, anxious, and responsible; middle children

are the peacemakers, the people-pleasers, and often feel left out; and the lastborn are most likely relaxed, sociable, and fun/playful.

Our family never discussed this theory, yet I see many traits in my sisters and me consistent with Dr. Adler's suggestions. Although I'm an introvert by almost everyone's standards, I'm the most extroverted and sociable in my family by far. I've also felt, from a very young age, that my primary role in the family was to lighten the mood. Having fun was not a core value of my family of serious academic introverts. I would often find ways to crack a joke, make someone smile, or change the topic of conversation to a more uplifting one. If my mom was having a bad day, I would run up to her bedroom and tuck one of my stuffed animals into her side of the bed, with its head resting gently on her pillow. Her bedroom was right next to mine, and I would lie awake silently, like that stuffed animal, until she retreated for the night. I could hear her laugh when she entered her room and saw her pillow, and nothing made me happier. Childhood family photos are filled with my exaggerated smiles as I tried to make the camera holder laugh. In middle school, I'd buy packs of pocket-sized joke cards from Spencer's Gifts in the mall to hand out when friends needed a laugh. I felt a quick release of dopamine every time my family laughed or my friends chuckled at my antics. At the time, I was oblivious to the birth order box I was checking off.

The summer I was twelve, my aunt got sick. Mom flew to Pittsburgh to be with her at the hospital. Aunt Barbara took an unexpected turn for the worse and passed away at the age of forty-three. My father was home with my sisters and me

when he told us the news that evening over dinner. We were all quite somber. While I had only seen my aunt a few times since we had moved from Pennsylvania to Florida seven years prior, I had many positive memories of her and knew how close she and my mom were by the hours my mother spent talking to her on our kitchen phone. After a few minutes of silence around the dinner table, I tried to lighten the mood by saying how fun going to the beach would be next weekend with our friends. Nobody even smiled, and we spent the rest of the dinner in silence. We all finished eating and took our dishes to the sink.

I went upstairs to my bedroom and shut the door. I laid on my bed, trying to wrap my head around the fact that I would never see my aunt again. Except for the class bird dying on my weekend to take it home in nursery school, I had never experienced death and was in disbelief. I took the white-glazed ceramic piece my aunt had painted me for my first communion down from the shelf above my bed. The piece was an open prayer book with The Act of Contrition written in gold paint. I spent the next hour memorizing the prayer, hoping that she could hear me. I spent the next several days reciting this prayer in my head to keep my aunt close to me.

When my mom came home a few days later, she said she had to speak to me. This, I knew, was never good. What could she be mad at, I wondered, as she'd been away for the last week? She came to my room and told me how disappointed she was in me for not responding appropriately to the news of her sister's death. I was surprised as I had felt very bad about it and had thought of little else since being told of her

passing. Mom told me she'd heard I had quickly changed the subject upon hearing the news at the dinner table. "That was inappropriate and disrespectful. You should be ashamed of yourself."

"But I was only trying to lighten the mood," I explained.

"That is not your role."

"It's not?" How was I supposed to know when it was okay to be in my birth order box and when it wasn't? Friends and family had always encouraged my efforts to provide comic relief but now I was told that being in that box was not always okay. I was confused.

rewind

wo years after college, I was living with my boyfriend. We had known each other since I was nine, dating off and on since middle school and exclusively since junior year at Duke. We lived in a loft apartment in downtown Philadelphia, where I'd moved to pursue a master's in business at The Wharton School of Business at the University of Pennsylvania.

One afternoon, having just returned from visiting my twin in Charlotte, I was rummaging through our video cabinet filled with VHS tapes to find *Home Alone 2: Lost in New York* that I needed to return to Blockbuster before incurring a late fee. I noticed a VHS tape out of its box, turned upside down in the cabinet. I picked it up, thinking it must be the videotape I was looking for.

But when I turned the tape over in my palm, there was no label on it. I looked at the tape more closely and saw

two-thirds of the tape had been played. Curious to see what this tape was, I put it in our VHS machine and pushed Play. Pictures of a mostly off-camera man having very graphic, demeaning sex to (not with) a naked woman filled the screen. The camera lens must have been at 100X, zooming in so close to her body parts I hardly knew what I was watching. The camera zoomed back out a little, and I felt so nauseous I ran to the bathroom. When I returned, I rewound the tape to the beginning and fast-forwarded through the movie. I saw now, the tape had been stopped during the film's most graphic scene. I turned the videotape off and pressed Eject on the VCR.

It was the early 1990s, an era when you had to go out of your way to buy and view porn. It did not come to you passively as it does today. It was mailed to you in brown confidential paper, or you rented it at Blockbuster in the "Adult" section. The internet was not nearly as sophisticated as it is today, and unrequested content wasn't pushed to you.

I had little exposure to or interest in porn. I had seen porn magazines lying around at my boyfriend's fraternity house on my trips to visit him in college. Many of the fraternity brothers, including my boyfriend, had posters of near-naked women adorning their bedroom walls. Women being objectified had always bothered me, and being around these pictures often left me feeling inadequate and uncomfortable.

Because I had seen porn at my boyfriend's fraternity and I knew how it made me feel, we had agreed, at my suggestion, when we moved in together, there would be no porn in our home. Now, at age twenty-three and living with my boyfriend for six months, we were talking about marriage. Standing in our vaulted living room in our loft apartment, I was dumbfounded. This was a clear violation of an agreement we had made just months earlier.

I waited nervously for my boyfriend to come home. Forty long minutes later, he unlocked our apartment door, and I met him in the kitchen, tape in hand.

"What is this?"

He looked down at the tape with no label. "I don't know. It's probably some movie I copied for us to watch."

My brain yearned to believe he didn't know what the tape held but my body would not concur, instead shifting into high-alert status.

I put the tape into the VCR player and slowly pressed the black Play button. When images appeared on our large TV, his face winced.

"What is this?" I asked again.

"Umm, it must have come from the fraternity house. I had no idea it was here. Really."

"But we've moved twice since April." The tape would have had to have made it through two moves. Twice he'd had the opportunity to throw the tape away. This tape was outside of its box cover, which suggested it had been viewed recently as I had never noticed this tape in our cabinet before.

"Bets, I don't know what else to tell you."

We went to bed in silence.

After a week of uncomfortable tension, he agreed to go with me to see a counselor through an employee assistance program offered at my work. I'd never been to a therapist before and was anxious. We arrived early and waited quietly in her small, dated waiting room. At our appointed hour, she greeted us and led us back to her office. She was a plump lady in her mid-sixties wearing a pale green polyester suit, her bun of hair tightly perched on the top of her head. I explained the

incident with the porn tape and my discomfort at not only finding porn in our home but also for my boyfriend crossing a boundary we had mutually agreed upon.

She listened, paused for a moment, and turned to me. "Betsy, you have to understand. Men are visual. This is not uncommon. You need to accept it. Is there anything else you'd like to discuss?"

I looked at my boyfriend, and he looked at me, but neither of us said anything.

"Uh, no, no. I think we're good. Thank you," I said.

Our appointment lasted all of ten minutes. As we walked back to our car, I told my boyfriend I didn't care if it was common. Prior to moving in together, we had agreed there would be no porn in our home. I was confused as to how a therapist could think it was okay to blatantly cross a relationship boundary designed to help me feel safe. I knew I could not live with porn in my home and told my boyfriend on the way home it was either porn or me. My boyfriend chose me, and we drove back to our apartment in silence.

I thought I would feel relieved after that meeting, but I didn't. My boyfriend agreed to stop watching porn only because I had made a threat, a threat I would have carried out. But deep within me, I pushed down the question that kept trying to surface: *Betsy, do you really want to be with a guy who thinks porn is fine and doesn't see how it perpetuates the objectification of women and hence me, his future wife? Someone who can ignore how porn normalizes violence against women and children? And what, Betsy, are you going to do if you have daughters with him—do you want them raised by a father who thinks it's okay to put women in this box?* Conflicted at twenty-two years of age, I tucked these unsettled feelings deep into my pocket and carried on with life.

wedding

We were engaged a few months after I found the porn tape in our apartment. My boyfriend had tried to propose several times, unbeknownst to me. I was in business school and repeatedly canceled our dinner plans to participate in group study projects. One evening, I met him at the food court across from campus to get a slice of pizza. Afterward, he took me to a fountain in a popular public square in downtown Philadelphia. It was late and dark, and I was exhausted and a bit frustrated that he had insisted we look at a fountain in a square we had never been to before for no apparent reason.

When we arrived, the square was filled with homeless people, and I just wanted to go home. I turned around to tell him this and saw he was holding a diamond ring in his hand. He asked me if I would marry him. I was stunned. I didn't say a word. He thought I was in shock because he'd asked me

to marry him, but I wasn't. I'd seen the receipt for the ring he was holding on top of our bedroom dresser a few months earlier. I was speechless because I could not believe this was how I was getting engaged. Staring at him blankly, he asked me again, "Will you marry me?

"Yes," I said. "Yes, I will marry you. Can we go home now?"

We married three months later over the Christmas holidays. It was a convenient time as I was on winter break from classes and had not desired a long engagement. By now, my boyfriend and I had been living together for eight months since he returned from a hardship navy tour in Iceland. On the day he left, he told me he planned to ask me to marry him when he returned. A year and a half later, when he was stationed in Philadelphia, I moved from Florida to be with him, thinking a ring was imminent. Months of living together went by with no ring in sight while my mother kicked me out of the good girl box for living in sin and told me I was foolish and simply wanted to play house. Once engaged, I was anxious to marry to redeem myself. My mother, while overjoyed, assumed I must be pregnant because why else would I want to plan a wedding in three months?

My mom and dad gave us $18,000 for the wedding. They told us we could keep what money we didn't spend. One afternoon, I drove myself to the mall and bought a wedding dress in a discount formalwear store for $200. Because we were having our wedding in a Catholic church over Christmas, we didn't need flowers as the church would be filled with red and white poinsettias. I made our wedding cake, a family friend with a passion for photography took the pictures, and a designated guest used our camcorder to shoot video. We held

our reception at a small Italian restaurant in our hometown, and a friend of the family sang for entertainment. Forty-five of our closest family and friends were invited with the rule that no one could bring a guest we didn't know—neither of us wanted to meet someone for the first time on our special day. We spent $3,000 on the wedding and used $15,000 as a down payment on our first house.

My mom was mortified when she heard our plans. She said my wedding would be an embarrassment to her and asked me repeatedly why I refused to use the money she and my father had given me to hold a proper wedding. "Because I'd rather have a house than a party" was not a rational explanation to her ears.

I have no fond memories of our wedding day, as the only thing I could think about was how much I was embarrassing and disappointing my mother. When my dad walked me down the aisle, my prevailing thought and wish was I hoped this fiasco would be over soon. Immediately after dinner and the cutting of the wedding cake, I told my now-husband I wanted to leave. We got into our little cherry red beat-up car that someone had shoe-polished "Just Married" on the back window and drove a mile to a bed-and-breakfast. Emotionally exhausted and physically drained, we fell into bed and went to sleep, neither of us in the mood to consummate our union.

The next day, my mother called me, elated. She told me how lovely the event was and how several of her friends raved about the beautiful flowers, cake, and venue. Although I had hated every minute of my wedding, I was relieved I had not embarrassed my mother or strayed too far outside her version of the ideal wedding box.

reveal

I was at my obstetrician's office in Phoenixville, Pennsylvania, twenty weeks pregnant with our first child. This was our big day, the day an ultrasound would reveal our baby's gender. For the past seventeen weeks, I'd heard both my mother-in-law and my husband tell me how much they hoped it was a girl. My mother-in-law, from Venezuela, never had the daughter she'd always wanted and was hoping she could be *abuela* to ours. She'd already picked out the gold earrings her granddaughter would leave the hospital in. And ever since I had known my husband, he always wanted to have a girl. This desire had only increased with each passing week of my pregnancy.

I was now lying half-naked on the cold exam table in stirrups, filled with fear. What was I going to do if I was carrying a boy? I'd let them both down. They'd be disappointed not

only in the news but also in me, as though I failed them in some way. At the same time, I knew this kind of thinking was crazy. Most moms-to-be were excited on this day, hoping only to carry a healthy child. Here, I was worried I might be carrying a child of the wrong sex.

What no one knew was the reason I'd been adamant about finding out the gender: if I was carrying a boy, I wanted my mother-in-law and husband to have twenty weeks to digest this news so nothing but positive energy welcomed our baby on delivery day. With my in-laws and husband standing over me, the OB rolled the wand around on my shivering stomach like a skater doing figure eights.

After a few moments, she stopped the wand, moved it again, stopped again, and said, "Are you sure you want to know?"

"Yes," I said.

I looked up at the OB with pleading eyes and said a silent prayer. She smiled and said, "You are having a girl."

My mother-in-law squealed in delight and then started to cry. I cried, too, but my tears were not of joy but of relief and shame. Relief I had not failed them with a boy. Shame for caring if I had.

doughnuts

Despite reading *What to Expect When You're Expecting* and taking Lamaze and infant massage classes in preparation for our first child's arrival, many things surprised me once I became a mother. I went into the hospital one evening after my water broke and came home a day later with a baby in tow and two excruciatingly painful lumps the size of lemons coming out of my ass.

I had to ask the nurse what the lumps were. When she told me, I instantly thought of the trading cards I saw at Spencer's Gifts store when I was in middle school that said: *You should have been a hemorrhoid, you're such a pain in the ass*—a card I never understood until now at thirty years of age.

"Well, how do I get rid of them?" I asked the nurse.

She laughed and walked out of the room. I wasn't sure what was so funny.

On the way home, my husband said he was stopping to get me a doughnut. I told him thanks, but no thanks, as I wasn't hungry. He laughed. "Not that kind of doughnut," he said. At the pharmacy, I waited in the car with our newborn Maria. He came back with an inner tube, like the kind we used as kids to float down the spring-fed Ichetucknee River near our home. "This will help you sit more comfortably," he said. "You know, until they recede." No, I did not know.

Hemorrhoids weren't the only thing I was not expecting when I was expecting. Nursing my daughter did not go smoothly either. It did not prove to be the natural, peaceful bonding experience I had read about, as Maria would not latch on but rather preferred to bite down ferociously and not let go. Soon, my nipples were raw and bleeding. When they weren't pulsating and throbbing, they were spouting out milk like a garden hose gone wild. How could something supposedly so natural be this hard? A few weeks postpartum, and I was already failing in the mom box.

Looking for much-needed support, I joined a few playgroups. Walking in late one morning to one of them, I overheard, "I know. She had to have a C-section last week."

"How sad. She really wanted to experience a real birth," another mom replied.

"What do you mean?" I asked, unstrapping Maria from her car carrier.

"Well, you know, having a C-section is not *really* delivering a baby."

"It's not? What is it then?"

"It's taking the easy way out."

Over the next few months, I heard mothers one-upping each other with their harrowing birthing stories, women putting down other mothers for having an epidural, or three, women competing over whose child was reaching certain milestones first and seemingly taking credit for these achievements or looking dejected if her baby had not yet reached one. Looking for support in these groups, instead, I found shame, judgment, and narrow, specific criteria for the "good mom" box. Why were we comparing ourselves and our children, taking credit for things largely out of our control? Why were we not celebrating the children who would each make their unique mark on the world?

Another criterion of the "good mom" box revealed itself in my decision to return to work. Overhearing snide comments about moms who lacked dedication to their families for no longer being in the playgroup or sending their nannies because they returned to work, I started carrying guilt for not wanting to be the traditional stay-at-home mom that many of my neighbors were. Since graduating from business school, I had been the primary breadwinner of our family and also the one with employment that offered comprehensive family benefits. We could not afford to give that up, nor, more importantly, did I want to give up my career. Despite having been raised by a stay-at-home mother, I had never seen motherhood and a career as mutually exclusive. After three months of maternity leave and being banned from the "good mom" box, I stuffed my guilt in my pocket, packed my breast pump in my briefcase, and returned to work.

part two: unpacking

Part Two: Chapter III

ovals

With the money we saved from having a modest wedding, my husband and I built our first home in Collegeville, Pennsylvania. We had an oval oak table in our kitchen. This table was a labor of love. While I was in graduate school, we had little money, all of which went toward the down payment on an adorable two-story colonial on Stine Drive. One Saturday, I drove our white cargo van to an auction of a nearby motel that recently went bankrupt. When I went inside the shady motel, I didn't see anything that interested me to bid on. As I was leaving, I walked through the motel's break room and, like lovers from across the room, I spotted her. A beautiful-to-me table with six chairs. With a little TLC, I envisioned this table being the focal point in the kitchen of the home we were building. With $125 cash in hand, I outbid everyone to be the proud owner of a beat-up old oval wood table and six bucket chairs. From the

van, I lugged the table and chairs up three flights of stairs to our downtown loft apartment in Center City Philadelphia. Four laborious weeks of stripping and refinishing (and many neighborly complaints of the toxic fumes from the harsh chemicals) gave my table and chairs a second life. We proudly placed this oval table in the eat-in kitchen of our new home.

Excited to have company in our new house, we invited my in-laws from Florida to visit us for a week. After a day full of activities downtown, my husband and I spent the afternoon in our pink-striped wallpapered kitchen making chicken fajitas for dinner. With the chicken and vegetables grilled and accouterments ready, I called my in-laws to come downstairs from the guest bedroom to eat. My father-in-law took a seat at one end of the oval table while my mother-in-law prepared his plate, a custom of theirs for which I had little patience. Since I was nine years old, I had watched this woman work full-time at an ophthalmologist's office while her husband lived his days in a large recliner watching the news blaring from the television. She prepared every meal for him, set it in front of him at the table, and then cleared his plate when he was finished.

When I approached the table, plate in hand, I sat down beside my father-in-law. He turned to my husband and said, "I'm sitting here, Son; you sit at the other end of the table," pointing to the other end of the oval table.

Confused because my husband and I had never sat at the far end of the table, I asked my father-in-law, "Why?"

"Because he's the head of your family, Betsy. That's where the head of the household should sit."

Gripping the table in front of me to keep my balance, I looked at my father-in-law in disbelief.

"Why is he the head of our family? Because he has a penis?"

There was dead silence at the table.

Finally, my husband said, "Dad, we don't do that here," pulled the chair out beside me, and sat down, leaving the seat at the head of our oval table vacant.

What does head of family, head of household even mean? Legally, the phrase refers to the one that makes the majority of money and, hence, financially supports the household. Since graduating from business school, I had been the bread-winner in our family. After we had children, my husband and I agreed that he would be the stay-at-home parent while I went back to work. Legally, the head of household would have been me but my husband and I had never viewed our roles like that.

I soon got rid of that oval table, and, to this day, I buy only round tables, where no seat at the table connotes dominance. Patriarchy will never have a seat at my table.

hell

My husband and I separated when my daughters were one and two years old. He and I decided to move from Philadelphia back to Florida, where we'd be close to extended family and wouldn't have to shovel humidity. While waiting for my divorce to be finalized, the first thing I wanted to do was have my children baptized. Raised Catholic, I had an urgency about this. I feared if something happened to my daughters and they weren't baptized, their souls would stay in limbo forever. I also feared my now former husband would intervene if he found out the girls were going to be baptized. He was baptized, was raised Catholic, and we were married by a Catholic priest in a Catholic church, but a year before we divorced, he became an atheist.

I called the Catholic church I had been raised in. They told me I would have to join the church and take a series of classes before they would baptize my girls. I didn't want to wait, so I church-shopped and selected a United Methodist church many of my childhood friends were raised in and spoke of fondly.

I was raised a strict Catholic, never missing Mass, even while on vacation in foreign countries. I do recall, as a child, not being fond of going to Sunday school or Mass, and so it appealed to me that my friends at the United Methodist Church enjoyed going to church in their youth. I was worried about how my mother would feel if I raised them in a religion other than Catholicism, but also craved an environment my children would seek out rather than be led. I visited this Methodist church with my children and immediately felt at home. They welcomed us instantly, gave us a tour, and said my girls could be baptized as soon as I wanted. We picked a date a few weeks out, had some friends and family come, and we had a wonderful spring baptism for my daughters.

Soon, my girls and I became active members of the church, me teaching and my children attending the Wednesday evening and Sunday morning programs. I was also asked to be on the church's Board of Trustees, which I gladly accepted. One day, I called the church to tell them I could not teach that afternoon. I felt awful giving them such short notice to find a replacement.

"Betsy, we don't do guilt here," Aubrey, the head of youth ministries, said.

"What?" I said, not thinking I heard her correctly.

Aubrey said, "No worries at all, Betsy. We don't do guilt here."

My heart skipped a beat; I suddenly felt lightheaded, weightless. "Really?" I asked.

"Yes, really."

I closed my eyes and saw a bird being released from its cage, its wings carrying grace, peace, and acceptance to me. One of my boxes had opened. I had never felt more loved.

A few years later, in the spring, I called my mother to invite my parents to attend Easter service with us.

"I'd love to, Betsy, but we can't," my mother said.

"Okay, but weren't you planning on going to church?" I had never known my mother to miss a Sunday.

"Yes," she said. "You know I never miss Mass."

"I just thought, being Easter and all, you might like for all of us to be together," I offered.

"I would join you, but then I'd go to Hell, so we'll just meet up for brunch afterward."

I held the phone away from my face, stunned in disbelief.

I slowly brought the phone back to my ear. "What?"

"If I miss Mass, I'll go to Hell, so we can't come."

At thirty-five years of age, I finally knew why my mother insisted we never miss Mass as kids. In all my childhood travels with my family, it did not matter where we were or what country we were in, my mother found us a Catholic Mass to attend.

"Betsy," she continued. "I have a question to ask you."

"Sure, Mom, what is it?"

"I know this is an odd question, but I'd really like to know. How are you comfortable going to a Methodist church knowing you are going to Hell if you do?"

At first I thought she was joking, but quickly realized she was being sincere in her inquiry. She had seen a glimpse of my life loving God without fear and she wanted to experience that. It was the first time in my adult life I felt sorry for my mother. I didn't believe the God she raised me to believe in was going to punish me for preferring a Methodist service over a Catholic service, or even going to a service at all.

"That is just not the God I believe in, Mom."

"Oh, okay. That must be nice."

"Now I have a question for you, Mom. Have you been so diligent about attending Mass out of your love of God or out of fear of Him?"

"Fear," she said without hesitation. "Fear of going to Hell."

Twenty-three years later, at eighty-three years of age, my mother has still never missed more than a few Masses in her life. Since COVID, she watches Mass on TV. I had always assumed her love of God kept her going. Knowing her relationship with God for over eight decades had been built on fear has brought me heartache as my mother may die never feeling the grace of God's love.

check, please

was at my first doctor's appointment since my divorce. The receptionist was wearing a blue name tag with the word "Cindy" written across it in red. She asked my name.

"Betsy," I said.

"Last name?"

"Pepine. My last name is Pepine."

More than anything else I received in my divorce settlement, this was what I valued most. Getting my maiden name back… the name I was known by for the first twenty-three years of my life, and the name that will be etched into my headstone upon my death.

"I can't find you in our system," Cindy said.

"Oh, I'm sorry. You probably still have me under my married name." I spelled my married last name for her.

"Found you."

After checking me in, Cindy handed me a medical intake form to complete. "We need you to update your medical information for us," she explained.

I found a free chair in the stark waiting room, sat down, and took a look at the form. The form had all black-and-white print, except for red asterisks denoting mandatory fields. I started filling in the usual blanks—Name*, Address*, DOB*.

Then, I read the next field.

Marital Status*

- ☐ Single
- ☐ Married
- ☐ Divorced
- ☐ Widowed

I stared at what should have been a fairly straightforward question and felt my stomach grow queasy. I've been asked this question on countless forms and had never given this question much thought prior to going through my divorce. Now, I was offended by it and surprised by my body's physical reaction to a common question.

What was I now? How did I squeeze everything I had been through into one simple box? It's just not that simple a task. They were asking me to check a box, but I knew the minute I checked a box, I was putting myself in that box, a box whose label conjures a myriad of different things to different people, depending on who you asked.

How dare they demand I put myself into one of their prescribed boxes? Legally, I'm divorced. But I'm also single. I've now been single for forty-six of my fifty-five years on this planet. How long do I have to be divorced before I am deemed single again?

And where is ☐ separated?

And ☐ other? Where the heck is the catch-all ☐ other?

Heck, why do they even need to know this information and shouldn't this information be optional to give if I'm choosing to do business with them?

I turned my medical history intake form in with the marital status question unanswered. The nurse called my name a few minutes later as the physician was ready for me. Apparently, how I define myself does not impact his ability to give me a Pap smear.

Years later, I was talking to a gentleman on the phone who lived in another city who I'd met on Match.com. After a few phone conversations, I sensed something was not adding up with his marital status, so I looked him up on the dating app to check his profile. It confirmed he was divorced. Still thinking something was amiss, I looked up where he lived to see who owned his house. From the public property appraiser site, I saw his house was in his and another woman's name. They shared the same last name. While it could be his sister, it was likely his wife.

The next time we talked, I asked him again, "So, are you divorced?" hoping he forgot I had asked him this on our first call.

He paused for a bit and then said, "Yes, I am divorced."

"But what?" I said, sensing something had been left unsaid.

"I am divorced from my first wife, so technically, I'm divorced."

The word "technically" did not sit well with me.

"What does that mean?" I asked.

"Well, I am married to my second wife, but I divorced my first wife to marry her, so yes, technically, I'm divorced."

He, too, seemed confused by the marital status box.

girls

It was 1992, and I was twenty-two years old. Before going to business school, I worked for CSE Consulting in Philadelphia. I was staffed on a project at Rosenbluth Travel in Center City Philadelphia for four months, tasked with writing a computer program for the company's meeting planners that would ease the logistics of their communication with their repeat travelers. My job culminated in a presentation to the meeting planners to demo the product I had created for them.

I was nervous. This was the first client presentation I had ever given. For four months, I had lived and breathed this project and knew the program inside and out. The presentation went flawlessly, and after a lengthy Q&A, I returned to my cubicle exhausted. An hour later, my boss Karl asked to debrief with me. He shut the door as I sat down in his office.

"Your presentation went really well. Congratulations. The meeting planners had a little feedback for you that I'd like to discuss."

"Sure," I said, thinking they wanted some modifications to the code to fine-tune some of the functionality of the program.

"The issue, Betsy, is that in your presentation, you repeatedly referred to the meeting planners as 'girls.'"

"I did?" I said, not really remembering how I referred to them. "I'm so sorry. I didn't realize there was a man in the room. I only saw females."

"You are correct, Betsy. There were only females in the room, but you referred to them as girls."

"What should I have referred to them as?" I said, not understanding.

"Women," Karl said. "Any female eighteen years or older should always be referred to as a woman. It's demeaning to refer to adult women as 'girls.' Girls are children. Meeting planners are adults."

"Wow. Okay. Thank you, Karl. I never thought about that before. Many of my girlfriends are their age, and I refer to my friends as girls and girlfriends, so I didn't think anything of it. I meant no disrespect."

"I know you didn't. But you need to be careful about the labels you use. Let me ask you something. Would you ever refer to a group of adult men as boys?"

"No, never," I said as I realized quickly, embarrassed.

"Then you should never refer to a group of adult women as girls."

At twenty-three, I didn't realize the nuances of such labels. Since that day, I have tried hard to not make this mistake,

and I insist our staff use appropriate labels. When I do hear people referring to women as girls, I find it disrespectful and demeaning, even when I know they mean no harm.

A few years ago, a popular mortgage lender in town presented his services to the real estate agents in our brokerage during our weekly team meeting. He brought a few of his female associates with him. Throughout the presentation, he referred to these women as "his girls," and I cringed, feeling myself get hot from anger. For this reason alone, I have never sent him business. Too bad he doesn't have a Karl to coach him.

shirts

recently asked my sales manager to order shirts for our staff and agents. He used to work for a national uniform company and knows the apparel industry well. When I reviewed the order, I saw he was ordering all unisex shirts. I called him into my office.

"Luke, I reviewed the shirt order, and I'd like you to order women's shirts for our female employees."

"I did," Luke said, showing me the invoice.

"Luke, I see an order here only for unisex shirts."

"That's correct. Unisex sizes mean it fits both women and men."

I am not a moron. I know what unisex means. Wikipedia defines unisex clothing as "clothing designed to be suitable for both sexes in order to make men and women look similar." No, Wikipedia, that is not correct. Unisex sizing is designed to make women look similar to men.

"Have you ever worn a women's cut shirt, Luke?" I said, mustering restraint to control my irritation.

He chuckled. "No, it would never fit right."

"Correct," I said. "Many women feel the same way about unisex shirts. They never fit right because they are men's shirts slyly marketed to women as unisex."

Have you ever once seen a women's cut shirt marketed as unisex to men?

shoes

play pickleball. The other day, my friend Mark came over to my court to play. Mark and I are both avid runners. He had just come from running five miles and was still wearing orange-cream sherbet-color running shoes.

"I love your shoes!" I said.

"Thanks," he said and then lowered his voice. "You know, these are women's running shoes."

Hitting the bright yellow pickleball back to me, Mark continued, "I always buy women's running shoes. I just buy them a size and a half bigger than my own."

"Really? Why?" I asked. As a child, my mother had to buy my shoes in the boy's section to get a shoe wide enough to fit my feet, but as I grew, my feet thinned out, and this hadn't been an issue for me for decades.

"Because that is where I find pastel-colored shoes. Have you ever noticed men's running shoes come in such dark and

somber colors? They look so heavy. I want to run in shoes that look light."

Mark sprinted to my dink shot in the back corner of the Kitchen. "The only thing I have to make sure of is that the soles aren't pink. Too feminine."

After we finished playing pickleball, I googled men's running shoes and clicked on the images tab. Page after page showed men's shoes in navy, black, and gray. There were a handful of shoes that were different—one neon shoe, one bright blue one, and one that was Christmas red. But Mark was right; the overwhelming majority of men's shoes were in somber dark blues, blacks, or grays. How had I never noticed this?

Mark can't find colors he likes in men's running shoes, so he resorts to buying women's shoes but draws the line at pink soles because he views pink as too feminine a color for a heterosexual man to wear. Having only daughters, sisters, and aunts, I sometimes forget the boxes that men are also put into too.

rainbows

When I grew up in the 1970s, rainbows and unicorns were all the rage. I loved them both, but especially rainbows. I had a blue puffy pencil case with a rainbow across the top cover that I carried to elementary school every day. For Christmas, Santa brought me spiral notepads in the rainbow palate. My favorite tee-shirt had a silk-screened glossy, glittery rainbow decal on the front and my name in navy blue stenciled letters across the back. And my favorite movie was Disney's *The Muppet Movie,* where Kermit the Frog belted out the beloved "The Rainbow Connection" song.

Forty years later, I still love rainbows. Last year, I bought a PopSocket for my phone with the saying "BE KIND" on the top, with each letter of the phrase in a different color of the rainbow. When I first saw the PopSocket, I smiled. The saying and its bright colors made me happy. It reminded me of my youth and the rainbows I'd see at the beach after a

light summer rain. I also liked the phrase BE KIND, as it was a gentle reminder to be kind to myself and others.

A few months later, I set my phone down on a counter, and the person with me said, "I didn't realize you were a lesbian."

"What?" I said. "You know I'm not."

"Oh, I thought you might be trying to tell me something with your new rainbow PopSocket," my friend said.

While I hadn't viewed my PopSocket to be rainbow-themed, ever since the LGBTQ community adopted the rainbow flag, I had found myself consciously avoiding buying things with a rainbow motif. I had passed on beautiful candles, notepads, and towels with rainbow patterns I loved for the very reason that people might think I'm gay. My behavior bothered me. I forwent buying things I loved out of fear of what people would assume.

I'm fine with the fluidity of sexuality and have numerous gay friends, neighbors, clients, and tenants, and both my daughters are gay. But I am not gay, and being a single, heterosexual female, I didn't want to unintentionally send a message to the universe that I prefer to date women. So, I found myself putting back a rainbow yoga mat even though I really wanted it, aware of the irony that the symbol for inclusion had now become exclusionary for me.

I despise such boxes I bump into, the assumptions made, and the influence I sometimes still allow them to have on me. At least, now, I give myself grace as I'm more conscious of them and recognize when I'm being influenced by them. I bought that rainbow yoga mat off Amazon.com, with pride no less, and have been toting it to my hot yoga class ever since.

reviews

Several years after my divorce, I put myself on Match.com to meet men and, hopefully, find someone with whom I enjoyed spending time. Creating a profile on Match requires checking a lot of boxes—boxes describing ourselves and boxes describing what we are looking for. After completing my profile and uploading my pictures, I started corresponding with men on the website. I went out to dinner with a couple of guys but didn't click with them. Then, I received a message that I had a match and a gentleman named Adam reached out to me. We messaged back and forth a few times and realized we knew many of the same people in town. In my profile, I had specified that I wanted the age range of my matches to be +/- nine years of my age, and although he was at the top of my specified age range, we had an instant connection and spent the first few weeks on the phone talking into the wee hours of the night. He was

intelligent and made me laugh. A few years older than me, he also had daughters a bit older than mine, with whom he shared custody with his former wife.

Our first date was a Sunday brunch at a quaint restaurant in downtown Gainesville, timed right before I had to host an open house in the event our connection didn't go as well live.

Sparks flew, and we agreed to meet again. Soon, we were seeing each other multiple times a week and talking on the phone on days we didn't see each other.

A few months after our first meeting, we were on the phone talking about our college experiences.

"What year did you graduate?" I asked.

"1979. No, I take that back. It was actually 1981."

"You don't know when you graduated from college?" I chuckled.

"I'm older than you; I forget these things."

A few weeks later, we were talking about birthdays, and I asked him what year he was born. He said 1957. I didn't think anything of it, but when we hung up, I felt something nagging me. I mentally did the math. Adam was eleven years older than me. If he was eleven years older than me, how had he matched with me on the dating site? Remembering I had taken a screenshot of his profile when we first matched, I looked through my photos on my iPhone to find it. He was forty-six. But if he was born in 1957, that made him forty-eight. I picked up my phone.

"Adam, I just realized something, and it's bothering me."

"Sure, what's up?"

"Well, your Match profile said you were forty-six, but if you were born in 1957, that would make you forty-eight."

The line went silent.

"Adam, are you there?"

"Yes. I'm here."

"So are you forty-six or forty-eight? I don't understand," I said.

Adam cleared his throat. "Well, I saw your profile and I really wanted to fit your criteria so I'd come up as a match. That way, you'd see me. I reduced my age to fall just inside the range you said you were looking for."

Feeling a bit ambushed, I wasn't sure how to process this. A core value of mine is integrity—my parents drilled into my sisters and me to be impeccable with our word, and my marriage ended due to a lack of integrity. While it was flattering he wanted to meet me, he could have reached out and explained he was a few years older than what I was seeking and asked if I was still interested in meeting him.

"Oh, I see. So, you lied about your age?"

"Yes, I did. But I did it to meet you. I didn't mean any harm by it. You looked really interesting, and I just wanted to meet you."

I took a few days to contemplate what to do. Was this a red flag or a simple, well-meaning transgression? Over the past few months, I had connected with Adam on so many levels, and we had such fun together. I had not laughed as much in years, and for the first time since my divorce, I felt hope that I could fall in love again.

Ultimately, I decided that, while checking the incorrect age box was inauthentic, a lie really, I would overlook it as he was just trying to make sure we'd connect and I was glad that we had.

We continued to see each other for the next year and a half and agreed to be monogamous. We spent most nights together and every weekend. He was fond of my daughters,

and we took them on cruises and ski vacations with his daughters.

A few months after our second Christmas together, my broker called me into his office. I'd known my broker since grade school, and we were friends more than colleagues. He closed the door and told me that a female friend of his had recently matched with Adam on eHarmony, another dating app. I was shell-shocked. I went home, thinking about what to do. The next day, I asked my broker if his friend had received an email from Adam or just a notification that she had a match from the app. He checked and said it was a system-generated email and that Adam had not reached out to her. I was relieved. I had been on eHarmony in the past and knew it could be months before I matched with someone. Adam likely forgot that he still had his profile up on the site.

I confronted Adam that evening, and he confirmed that, indeed, had been the case. But a few days later, the incident still nagged at me. I had spent the last two-plus years in my marriage being deceived by my husband. I would not allow myself to be deceived again. With my heart at my feet, I logged into Gmail and took a stab at Adam's password. After three tries, I guessed right, and his inbox loaded. I paused, wondering if I should proceed. Was it fair to look? And if I looked, what would I find?

I quickly scanned his inbox but saw nothing from eHarmony. I was about to shut my computer down when I saw an email from the day before from someone named Cindy. I held my breath. Was I really going to do this? Breaking

into his emails was questionable enough, but reading them? I pushed aside my conscience and clicked it open.

"I'm looking forward to our appointment tonight. How do I get in?" Cindy had written.

"The front door will be unlocked. Come in, and I'll be in the master bedroom off the kitchen."

"Great. Please have the cash on the kitchen table. See you soon."

My ears started ringing so loudly that I couldn't think straight. What did that mean, cash on the table? The only time I had to leave cash on a table was in Vegas when I was buying into a game of poker. I looked for more emails. I didn't see any from Cindy, but saw a host of others. After two hours of clicking and reading, I discovered Adam had been seeing prostitutes for years. One email I opened was from a prostitute he had hired several times while on various business trips to Washington, DC. His personal frequent flier, she had just moved to California and was starting up a new escort business there. In her last email, she asked if Adam would write a fake review on a website she was on to build credibility in her new market.

What was this website? She only referred to it by its acronym?

The clang in my ears was deafening, my freaking-out meter on overdrive. I typed the acronym into my search engine. Up popped the website, a review site of "the top community of escorts, hobbyists, and service providers. Find escort reviews, site reviews, discussion boards, live chats…."

Pain seared through my stomach from the internal gymnastics my abdomen was performing. When I clicked to enter the site, it told me I had to be a member to gain access. I reluctantly created a profile, pushing away my exhaustion and the pulsating shame that I had sunk so low. I waited

impatiently for the site to load, fearful my children would walk in on me. When the site finally loaded, I clicked on profiles of women that described their bodies, features, services, and prices. I also saw their reviews, where members rated and reviewed their bodies, services, hygiene, and more. Here, men recommended to other men who to try, who to avoid, who not to miss. I found the magnifying glass icon and typed in Cindy's name. I scrolled down to read her first review. The member's username was familiar, and I immediately knew it was Adam. He'd used a combination of his childhood nickname and his hair color. I then entered his username in the search bar. Up came the pages of reviews he had written on prostitutes he had hired over the years. The reviews spanned years and cities. In one, Adam wrote how he "took one for the team" when he booked a new prostitute that had no reviews. He warned "the team" to stay away from a prostitute who had the tendency to text clients unexpectedly when she was driving through the area. Apparently, she had texted him her specials and openings one evening on his way to see his girlfriend (uh, that was me). In another review, he shared his complaints that the thirty-year-old's escort's body was past its prime but could be gotten at a discount.

I was now numb. I felt as if I had been physically beaten and thrown out the back door like a bag of trash. Prior to this, my limited exposure to prostitution was watching the movie *Pretty Woman* and seeing prostitutes on the street corners of Vegas. I was floored that sites like this existed. I have since learned there are numerous others, just like this one, where men rate and review women like they would an online product. Women strive for positive reviews of their services and five-star ratings of their bodies, as that increases bookings and allows them to charge more.

I was stunned on so many levels. What clues had I missed? Years before, when my former husband was having an affair, I had suspected it. I felt it to my core. I repeatedly asked and was repeatedly told I was paranoid. After a year of asking, I was told I was crazy. After two and a half years, I discovered the truth. But I had suspected my former husband entered the betrayal box soon after he did. So when the affair finally came to light, while utterly crushed, I strangely felt some relief, knowing I wasn't crazy.

But this discovery, this one I never once suspected. Outside of his lying about his age to meet me, I saw no odd behavior, no excuses, nothing that would make me think he had a life other than the one I was a part of. I've learned this is common. Unlike affairs, which often involve emotional attachment and energy, large voids of unexplained time away, and unexplained phone bills or credit card charges, prostitution is different. It's a few hundred dollars of cash here and there. Adam and I didn't pool finances, so I never saw these cash outlays. Prostitute sessions, I learned, are typically one hour long. It's easy to be missing for an hour and not raise suspicion. I later found out Adam often visited prostitutes at motels on his commute to work in the morning. I'd have never suspected someone cheating on me at 7 a.m. on a Monday.

I was also stunned at the legality of all this. Prostitution is not legal in Florida, so how can a website that advertises such services and reviews of the experience be legal? Laws aside, substitute any other discriminated group, and this would be outlawed. A review site rating the services and body parts of Black people? A site reviewing Jewish people? A site reviewing the elderly? The handicapped? It would be outlandish, but it's somehow okay if it's reviewing women.

I confronted Adam with my findings when he came over the next night. I even spoke very slowly and methodically, the opposite of what I was feeling internally. I told him about everything I had uncovered, and he confessed to everything and more. He was distraught and knew he needed help. He admitted it was an addiction he had struggled with for over twenty years. I felt like someone had stabbed me in the stomach with a knife and turned it. Our relationship did not survive. His sexual addiction box was too heavy for me to carry.

watches

In my late forties, I dated a surgeon for three years. In the first months of our relationship, he told me he was insecure and emotionally distant and always needed to be dating someone because he couldn't stand to be alone. Instead of heeding my inner command to "Run!" I told myself I loved a challenge.

One morning, early in our relationship, I woke up and went to the bathroom. Coming out of the bathroom, I saw him propped against the headboard, watching me walk back toward the bed. He then told me I had passed the test.

"What test?" I said, confused as it was still early.

"I won't go out with a girl that doesn't look good when she first wakes up in the morning. But don't worry, you passed the test. No bed head."

"You cannot be serious."

"Yep. Life's too short. I can't be with a woman who doesn't look good at the crack of dawn."

There were so many red flags that, had I recognized them, I wouldn't have been able to carry them all. Instead, I focused on what I could see: he was well respected in the healthcare profession, had nice friends and family, his kids loved me, and he held hands with them while saying their dinner prayer.

When we started dating, I drove a silver Prius hatchback and wore a silver watch from Ann Taylor Loft. I loved them both. A year into dating, he told me that my car had almost been a deal breaker when we first met. Unbeknownst to him, this was my second Prius. I loved its gas mileage and low-key profile. He drove a Mercedes Benz, and during the first year of dating, he repeatedly told me that I deserved a more prestigious car and a better watch. A year later, I found myself the owner of a new white BMW and a silver Rolex, both of which I bought willingly with my own money. I told myself I had worked hard building my businesses, and I *deserved* these luxury items.

Prior to dating the surgeon, I had never cared about what kind of car I drove or what brand of watch I wore. I had never owned a luxury car, and once I did, couldn't understand what all the hype was about. And I felt like an impostor every time I wore the Rolex. I would find myself tugging on my sleeve to cover up the watch face because I didn't want people to see it. The brand's image was so inconsistent with my value of living simply and under the radar, and I felt uneasy every time I put it on.

My boyfriend also had an affinity for blondes. I knew this because he told me was infatuated with Britney Spears

and that he wanted to buy backstage passes to meet her in Vegas. I thought he was kidding until I saw a birthday post on Facebook from his surgical team, who had decorated his office with Britney Spears pinups. He also had a crush on talk show host Megyn Kelly and told me if he was ever in a room with her, I'd have to leave because he was not sure what would happen.

I suspect most women, upon hearing such things, would run. I'm an olive-skinned Italian with dark brown hair and even darker eyes. No one has ever confused me with being blonde. I did run after hearing all this, but instead of running away, I ran to my hair stylist and asked for blonde highlights.

Three years into dating him, I was turning forty-nine. He and his boys had recently moved two hours away, and they were coming to visit me for my birthday weekend. On the way to a party being thrown by a friend of mine, my daughters told me they had spoken to him and that he wasn't coming to town that weekend. When I called him, upset that he wasn't coming and that I found out through my daughters, he brushed me off, saying he had had a long week and they were going to stay home that weekend. That was the final straw. I could no longer be satiated by the crumbs he was feeding me. The next day, I canceled our upcoming vacation to Las Vegas, and we broke up over a short phone call. I immediately posted my Rolex on Facebook Marketplace and booked an appointment with my stylist to get rid of my blonde highlights.

Though I may have earned the money to buy a luxury car or watch, I had never asked myself if I had actually desired them. It was only after I owned them that I realized I had

never wanted them in the first place. Just because I could afford something someone else valued didn't mean it was right for me. I berated myself for willingly conforming to someone else's box of ideals. How could I be in my forties and still contorting myself to fit in other people's boxes?

Looking back, I had to ask myself why I stayed as long as I did. I stayed because I saw but demoted red flags to yellow flags. I compared him to my past partners, who had major issues with infidelity. The things this surgeon said or did paled in comparison. In addition, he checked all my boxes. He was smart. He was a family man. He held his boys' hands in prayer before dinner every night. He emailed his mom every morning to see how she was doing. He was even a surgeon. Sadly, this last one gave me an artificial bolt of self-esteem I didn't know I needed. With my father and both of my siblings being physicians, I had felt tremendous pressure to become one, too, but at least now I was dating a physician. And, because everyone, my friends and his, told me what a great guy he was, I was hanging on in the hopes that things would change. It took me a few years to realize a "great guy" doesn't always make a great partner.

While dating this man, I felt like a compressed mattress, the kind you buy squeezed in a box so small you swear you mistakenly bought the kid size. It only fits in the box when it's shriveled up, and the box is taped shut. Once you open the box, the mattress slowly takes in air, and after a day or two, it has naturally expanded to the king-sized shape it was meant to be. I was that mattress, making myself uncomfortably small to fit inside a box not meant for me. Tearing open the box, ridding myself of the Rolex and the relationship, filled me up such that I could never fit inside that box again.

schedule

My twin sister and I started playing soccer in fourth grade. We started running that same year to get in shape for soccer. We picked up tennis in middle school and I lettered in those three varsity sports in high school. When we both went to college at Duke, we fell in love with another sport—basketball. Coach K (affectionately short for Krzyzewski) was a basketball icon and was adored by the Duke student body. We saw Coach K and the men's basketball team regularly at the Oak Room restaurant on Duke's campus, where my sister and I waited tables. The now famous phenomenon of Krzyzewskiville (or K-ville) started the same year we started Duke as freshmen. Because Duke refuses to charge students for tickets and hands them out in a "first come" fashion, in 1986, students, the Cameron Crazies, began pitching tents and camping out prior to home games to ensure entrance. This fanatical

culture sealed our love of the game, and we've followed college basketball ever since.

My twin now lives in Charlotte, North Carolina, a few hours from Duke and in the heart of ACC college basketball. She recently texted me a photo of the TV sports schedule printed in her city's newspaper with a note that read, "What's wrong with this?"

BASKETBALL

Women's College Basketball NC State at Florida State. **6:00 p.m. ACC**	**College Basketball** Michigan at Iowa. **7:00 p.m. ESPNU**
Women's College Basketball Maryland at Indiana. **6:30 p.m. BIGTEN**	**College Basketball** Longwood at UNC-Asheville. **7:00 p.m. ESPNU**
College Basketball Minnesota at Ohio State. **6:30 p.m. FS1**	**Women's College Basketball** LSU at Missouri. **7:00 p.m. SEC**
College Basketball Drexel at Stony Brook. **7:00 p.m. ESPN2**	

The paper divided college basketball into two groups. College Basketball and Women's College Basketball. Why did the term "Basketball" refer to men's basketball and basketball played by women need a qualifier? Why wouldn't the term Basketball have two subcategories: Men's College Basketball and Women's College Basketball?

This prompted me to search for "college basketball" on the internet. The articles that appeared all referred to men's teams. When I clicked on the Images tab, the results included over two hundred images, all male. In 2024, how could this

be? Title IX banned gender-based discrimination, mandating educational institutions provide athletes equal access to financial aid. But newspapers can still reserve the term "basketball" to mean only people born with a penis? What is this saying about our society? To our children? To our female athletes? How can a generic name describing a sport played by all check only the male box?

Substitute any other marginalized group and ask yourself, would this be okay?

College Basketball
Longwood at UNC-Asheville.
7:00 p.m. ESPNU

Black College Basketball
LSU at Missouri.
7:00 p.m. SEC

Native American College Basketball
Michigan at Iowa.
7:00 p.m. SEC

Or:

College Basketball
Longwood at UNC-Asheville.
7:00 p.m. ESPNU

LGBTQ College Basketball
Minnesota at Ohio State.
7:00 p.m. SEC

These examples seem outlandish when applied to other groups but acceptable when applied to women. Why?

appearances

Last night, I watched a Masterclass on how to apply makeup. The makeup artist explained that proper skin care is the foundation of good makeup application and, to ensure our skin care routine is optimal, we must first determine our skin type. The three types of skin are dry, oily, and combination. Oh, and there's a fourth, he said as he whispered into the camera, "There is the mature skin."

Aging in America is not for the fainthearted. Especially for women. I recall the first time I heard, "You look great, Betsy, for your age," when I was about to turn forty. The disclaimer was so jarring and unexpected that it felt like a slap in the face. Note to all—this is not a compliment.

I had dinner with some girlfriends this past weekend, and we were discussing the boxes we have found ourselves in. Amy, a reputable attorney in town, mentioned the age box. She said her identity growing up was based on her good

looks and sex appeal. Gorgeous and in her sixties, she's struggled to create a new identity in a culture obsessed with youth.

People in the public eye have often commented on this life transition, and while it affects everyone, women suffer more than men. Female news anchors and actresses see diminished opportunities well before men of the same age. The American Association of Retired Persons (AARP), in 2021, reported that 90 percent of workers surveyed say age discrimination is common. Sixty-four percent of women and 59 percent of men surveyed stated they had personally experienced it.[1]

Although the age box is feared in our country, in other cultures, people rejoice in aging. Native Americans and Koreans celebrate aging and revere the elderly for their wisdom and knowledge. In Korea, the sixtieth birthday, hwangap, is a time of joy marking the passage into old age. It's celebrated with gratitude because many ancestors did not live to see this milestone. Another big family celebration occurs ten years later on the seventieth birthday. Known as kohCui, this birthday means "old and rare." The Chinese family unit takes care of the aging in a country where retirement homes are shunned. In India, most elders are esteemed heads of households and play an active role in raising grandchildren.

In the United States, with age discrimination and a youth-obsessed culture, many women color their gray hair. COVID stymied salon visits, and some women decided to let their dyed hair color grow out. Actress Andie MacDowell embraced her natural gray during COVID and opted to keep it when salons reopened. In an article for Vogue in July 2021 entitled "Andie MacDowell on Why Embracing Her Gray Hair Is the Ultimate 'Power Move,'" she said during COVID, her hair grew in dark and silver. She said, "I like to compare myself to George Clooney because why not?" I

love the burgeoning gray hair movement, but we'll never see an article on why George Clooney decided to go gray. The fact that a woman deciding to sport her natural hair color is so compelling to warrant an article in a major magazine is pathetic. It's equivalent to the ubiquitous red carpet question, "Who are we wearing tonight?" Ask us about our work and the impact we are making on the world, not why we are sporting our natural hair color. Engaging in such superficial questions perpetuates the beliefs behind them. We must shut down discussions like this to begin to dismantle the ageism box.

name

I was raised in Gainesville, Florida. The city was small, with a population of 122,000, when we moved there in 1974. My father, Carl Pepine, established himself at the University of Florida and, as the years passed, became a prominent physician known worldwide for his research and advances in the treatment of heart disease in women. Our family was active in our Catholic church, our public schools, city sports, and the medical guild. In addition, I was one-half of the "Pepine twins." We knew a lot of people, and a lot of people knew us. Being in the Pepine box was part of a strong identity I was proud of.

I left Gainesville with my sisters to attend Duke and then graduate school. After spending a college summer working for McNeil Pharmaceuticals in New Jersey, my plan was to work in pharmaceutical marketing after getting an MBA. My last name would serve me well in the healthcare arena because of my father's career.

In the fall of my first year at Wharton, at the age of twenty-three, I got engaged while pursuing my MBA in marketing and healthcare management. I had grown up in a traditional family with a long line of women taking their husband's surnames. But I was torn because I also loved my given surname and could not imagine not being referred to as a Pepine. I also knew I would have children and wanted our surnames to be the same. Eventually, I decided to vacate the Pepine box and move into my husband's surname box, naive of the implications this move held.

When we had our first child, the issue of her last name was never discussed. I had taken my husband's last name so she would have it too. Our second child was also given her father's surname.

When my daughters were one and two, I exited the marriage. Deciding what box I now wanted to be in was incredibly difficult. I wanted my maiden name back. I was a Pepine at heart. But I could not imagine not having the same last name as my toddlers. If I took back my surname and my husband remarried, my daughters would share their surname with their stepmother, not with me. People might assume their stepmother was their biological mom, and where would that leave me?

My estranged husband and I agreed we would add my last name to our girls' last name with a hyphen so our daughters would share both our surnames. Unfortunately, by the time our divorce papers were finalized, my former husband changed his mind, and I couldn't legally change my daughters' last name. With much anguish, I reclaimed the Pepine surname the day our divorce was finalized. Although our divorce decree stated our girls would live with me and visit their father every other weekend, I could not legally share my last name without their father's permission.

While writing this book, I became curious about the frequency of couples assigning the patrilineal surname to their children. Studies in 2002 and 2017 showed that 97 percent and 96 percent of heterosexual couples assigned offspring the patrilineal surname.[2] Interestingly, even in marriages where women kept their maiden name after marriage (a practice increasing by the decade), the majority of these couples still assigned their children the father's last name.

Despite the notion that this has been a long, steadfast tradition, this has not always been the case. Standardization of surnames did not exist in England (where US norms came from) prior to the seventeenth century. Surnames first appeared in England in 1066 and were often fun nicknames created by the person or their friends. They often described a person's occupation (Baker) or physical feature (Whitehead) or where they lived (Hilton=Hill Town). Sometimes, the names reflected their familial relationship (Margetson, son of Margaret). Only around the fifteenth century did surnames start to be inherited, and even then, it was common for mothers (and even grandmothers) to pass down their surname to their children and grandchildren. It was also not uncommon for husbands to take their wives' surnames, especially when inheritances on the wife's side existed.

Around the eighteenth century, signs of surname standardization started to materialize. Coverture laws that deemed wives to be property their husbands received upon marriage grew in popularity in Britain and barred women from owning land. In the US, the practice of taking our husband's surname upon marriage was adopted. By the nineteenth century, the practice of children taking the matrilineal surname nearly disappeared.

Lucy Stone is noted as the first American woman recorded to have kept her surname after marriage. This was

in 1855. "My name is my identity and must not be lost," she said. Not coincidentally, she was also the first American woman forbidden to vote because of her choice of surname.[3] In 1881, a New York court said that "the common law among all English-speaking people" required married women to take their husband's name.[4]

Today in the US, even though females are not legally required to assign their children their husband's last name, research done by Deborah Anthony at the University of Illinois at Springfield found that most court cases side with the father when battling over the right to pass down a surname, perpetuating the patriarchal culture.[5]

Taking the father's last name is *not* based on tradition, nor is it a universal practice. Many Spanish-speaking cultures pass down the last names of both parents. Icelanders don't have family names and instead, take on a name with a semblance to a parent's first name. Helguson might be the son of Helga.

The magnitude of the ramifications of the patrilineal nomenclature convention became obvious when I recently bought a subscription to Ancestry.com to build my family tree. After a few days of searching through the website's vast resources of historical records to find ancestors, it became obvious that patriarchal surname lineages were easier to uncover than female lines. Women could not own property until the 1800s and, until the 1900s, could not go to war, so many logs used to track history are void of women. Also, because women had (and still have) name changes with marriage, it makes tracing their history more difficult. This decreased volume of documented historical data on women undermines and minimizes the influence women had in history and respectively elevates the role men played. When I married, I didn't consider the implications my stepping into

my husband's surname box would have on my future history, as well as that of my children. How do we know where we came from and what great feats our female ancestors achieved when laws and norms make this information nearly impossible to trace?

part three: breaking out

work

When I was in my twenties and six months pregnant with my first daughter, Rhône-Poulenc Rorer, the pharmaceutical company I worked for flew me to Waikoloa Village, Hawaii, for their national sales meeting. I had to give five talks a day to a room of six hundred pharmaceutical sales representatives at a time, sharing with them the latest market share data on anticoagulant drug therapies and findings from our extensive marketing research. I also presented efficacy data showing our product reduced the incidence of deep vein thrombosis better than that of our competition and shared how to best convey this information when talking to physicians and other healthcare providers. I backed up this claim with promotional materials to be used as leave-behinds in physician offices.

Although young for my role at the company and facing an audience mostly older than me, I knew I'd nailed these

talks. Practicing for weeks prior, I knew the data cold. I antic-
ipated their questions and had responses ready for the Q&A
sessions following each talk. But after five presentations to
upward of three thousand people, I had only received one
question. From a woman in the back of the conference room
at the end of my third talk.

"Thank you, Betsy," she said after tapping the black
microphone, nestled in a stand halfway down the aisle, for
sound. "That was very informative. I just have one question
for you."

"Sure. What is it?" I said into the small mic clipped to
my blouse.

"I want to know where you got that adorable maternity
pantsuit you are wearing."

I slowly inhaled a deep breath of air and counted one,
two, three, biding myself time to override the harsh words
yearning to escape my lips.

I had traveled five thousand miles and spent countless
hours preparing this presentation and had just spent the last
forty-five minutes showing the audience data and promo-
tional materials that would propel their business to the next
level, and this sales rep asked me about my outfit? My skin
blushed profusely. If I hadn't been pregnant again, I'd have
thought I was having a mid-life hot flash. This was my first
time on stage in front of a national audience and I knew I
had to be tactful. I took another deep breath and smiled.

"Thank you. Thank you for asking. Now, does anyone
have a question relevant to my research?"

mission trip

Several years into my real estate career, I decided to join Rotary International, an organization with a mission to "provide service to others, promote integrity, and advance world understanding, goodwill, and peace through our fellowship of business, professional, and community leaders."[6] I joined to meet new people and be more involved in the local community. My former father-in-law had been engaged in Rotary, hosting numerous exchange students over the years, and was an active volunteer in our town, which spurred my excitement. I also wanted to help increase the population of female Rotarians, a goal of the local chapter and felt Rotary's core values of leadership, integrity, and service aligned with my own core values. I loved its Four-Way Test: all things Rotarians think, say, or do should be truthful and fair, build goodwill and better friendships, and be beneficial to all.

The initiation process was lengthy, as Rotarians vet applicants to ensure they have a respectful standing in the community and are committed to service. After attending a few meetings at the local chapter, filling out a lengthy application, finding a sponsor to endorse me, and being voted on by the board, I received my new member badge. I attended a mandatory new member breakfast and gave a required new member presentation to my fellow Rotarians to become a full-fledged participant in the chapter. After this rite of passage, of which I was proud, I volunteered on the public relations committee and began to volunteer at various fundraisers and community projects. I enjoyed the people I was getting to know and felt I was making an impact in the community. I also started taking classes at the Rotary Leadership Institute to learn the skills to help build a strong club as I hoped to advance up Rotary's leadership ladder.

Less than a year after joining, I was in the buffet line waiting to get lunch before our club's weekly Tuesday meeting. In front of me were two established members of the club. Jack, a married man in his late sixties who had held various leadership positions throughout his Rotary tenure, was talking to Paul, a man my age who had more recently joined. Our Rotary chapter had just funded several members to go on a mission trip to Nicaragua to help build schools and wells for water in impoverished communities. Behind them in line, I heard Jack ask Paul how the mission trip had gone.

"I had a great time," Paul replied.

"Good to hear," Jack said. "But the real question is, 'How were the women?'"

"Even better," Paul said, "because there, you don't have to pay them."

Jack laughed and said, "That's great to hear."

I turned my head around left and right to see if anyone was hearing what I was hearing, but everyone was paired up talking to someone else. Fairly new to Rotary, I was stunned. This Rotarian had asked another about the women in the developing country that he'd slept with while on a mission trip funded by Rotary as casually as he would ask, "What's for dinner?" I excused myself from the buffet line as my appetite abandoned me.

That evening, I called our Rotary president. Carol was a respected business owner my age, and her family had owned a reputable catering business in our town for decades. She answered on the first ring. I relayed the conversation I had overheard between Jack and Paul and expressed my concern that it didn't seem consistent with Rotary's core values or with Rotary's Four-Way Test.

Carol was empathetic and agreed how this could have been uncomfortable to hear as a new female member of Rotary. She went on to share that Jack had a well-known sexual addiction issue and suggested I not take it seriously. Shocked that Carol would reveal something so personal and that she felt this characteristic or "condition" somehow excused poor behavior, I explained how, being a fairly new member of the group, I did not feel this was an effective way to increase female enrollment, a noted goal of the group. She said she would be sure to let other members of the leadership team know about the conversation I had witnessed and would get back to me if she needed anything.

I never heard from Carol again, but I resigned a few months later. I could not be part of an organization that tolerates discussions about the quality of women a participant hooked up with while on a funded mission trip to a developing country. How does volunteering during the day to build

wells in impoverished villages sanction preying on these dis-advantaged women at night? The power inequity inherent when helping a population that has less than quickly turns into power over the poorer population, creating subordination and discrimination. Females are one of the last groups against which it's still acceptable to blatantly discriminate. Imagine if, instead, this Rotary leader had asked Paul: "What were the disabled like to sleep with?" Or: "How were the Black people in bed?" I sense Carol would have reacted to such a comment much differently.

Gender discrimination imprisons us in boxes filled with stereotypes. In this case, the messaging is one that's been reinforced consistently since I was a child: a female's value lies in her body, and because we live in a patriarchy, women will only rise to the extent to which their bodies are deemed of value by men.

dresses

My daughter, Maria, and I traveled to Atlanta last year for a session with a House of Color image consultant who conducts color and style analysis. I booked this session because I felt an incongruence between my external appearance and how I felt internally. My choice of clothing, makeup, and hair trended toward conservative, classic, and safe to ensure attention was directed elsewhere. Now, in my fifties, I felt as if I wore a costume every time I left the house. Some days, I wanted to scream, feeling helplessly constrained by the uniform in my closet. Where was that pig-tailed little girl grinning into the camera so full of joy she looked like she was going to burst?

A bubbly, spunky woman my age greeted Maria and me at the front door of a red brick colonial in a hilly suburb of Atlanta. After a quick tour of her lovely home, we settled into Rachel's office, where there were racks of beautiful

color swatches, layered trays filled with makeup, and an assortment of magazine spreads showing women in various fashion styles.

Rachel asked us what brought us here. I explained that since graduating from college, clothing decisions had been a struggle. Upon graduating from Duke University, I had accepted a position at Andersen Consulting in Tampa, Florida, knowing I needed to work for two years to get the requisite work experience for entrance into a top business school. The first three weeks at Andersen I spent in "the fishbowl" with my new best friend Jim. Jim and I started on the same hot summer day in August, and every day thereafter, we sat in the right back corner conference room of Andersen's corporate office with floor-to-ceiling windows on every side. From 8 a.m. to 5 p.m., we studied computer programming from a five-inch-thick hunter-green binder in this fishbowl, breaking only for lunch.

After six weeks of learning to write computer code, Jim and I were sent to a client site where we spent our days holed up in a windowless room writing programs to automate their advertising system. A month in, I got a call from Marie at our corporate office an hour away. Having never met Marie, she introduced herself as my mentor and asked if I would like to meet for breakfast the next morning. I agreed, excited about this employee perk I didn't know about.

Knowing first impressions were everything, I bought a new outfit after work that evening to wear the next morning. At 7:56 a.m., my sweaty palms and I were taking in the sweet smell of bacon in the lobby of Waffle House, waiting to meet Marie. I'd never had a mentor before and was excited that Andersen thought enough of me to assign one. Marie arrived, and we were seated at a booth in the back by the loud kitchen. After a high stack of chocolate chip pancakes and

lengthy chitchat about my family and life before Andersen, the bill came. Marie picked it up and paid the waitress for our meals.

It was now approaching 9:30 a.m., and I nervously but discreetly checked my watch. I was late for work and wondered if the client I was working for knew about this meeting. After a few more attempts at making small talk, I looked up and noticed Marie's face had changed from welcoming to pained. While this was my first "real" job out of college, I knew enough to understand this look was not positive. "Is there something you need to tell me?" I said, bracing myself. I thought I had been doing a good job. Was I about to get fired?

Marie smiled awkwardly. "Betsy, it's about your clothes."

Stunned, I could not imagine what the issue could be. My necklines were high, my hemlines were low, and my sleeves were long. I looked down at my new outfit, purchased less than sixteen hours before—a '90s oversized mauve blouse with shoulder pads and a matching skirt that landed just below my knees. My tan pantyhose felt itchy, and the blister on the back of my heel from my new black pumps throbbed.

"What do you mean?" I asked.

"People are complaining that you don't, uh... you don't look the part...."

"Oh, okay," I said quietly, looking down, not sure what she meant. I had never seen Marie in our office. Who could have called the home office to complain?

"What I'm really saying is that you don't look corporate enough." Marie stirred her water with the straw in the glass. "It's like you look like you are going to church, not to work."

I couldn't argue with that. Having just graduated from college, I had little savings, so I raided my mom's closet. She kindly gave me several dresses she wore to church, the

dressiest things she owned. A newbie to the corporate world, I thought "dressed-up" was "dressed-up" and failed to see the nuances of this phrase.

"I don't recall reading about an Andersen dress code during onboarding. Would you mind sharing it with me so I know what is expected?" I said.

"Well, that's just it. We don't have one," Marie replied.

"I see," I said, when really, I didn't. How was I breaking a dress code that didn't exist? "I'm not sure I understand."

"I know it's complicated. It's hard to define. It's like porn. You can't explain it, but you know it when you see it."

"Thank you, Marie," I said, nauseous and unsure what to do next. "Thank you for breakfast. It's great to meet you. I think I need to get to work now."

Marie looked up and shook her head. "No, you need to go home and change."

I drove back to my apartment in tears. No mentor program here! In my bedroom, I tore off my new mauve skirt and blouse and threw them on the floor. I yanked my closet door open and rummaged through my clothing to find the only thing I knew for certain would be acceptable—the navy blue interview suit I'd worn to get this stupid job. Like a prisoner restrained by a straitjacket, I wore that suit every day for the next two months until I could afford to buy myself a second one.

Now, in Atlanta, Rachel, the House of Color image consultant, nodded as she listened to my struggle to play it safer than who I really was with my wardrobe and appearance. Rachel then asked what my goals were for the day. I opened my purse and pulled out my homework. "Here," I said, shoving a picture into her hand. The picture was of a girl, around the age of four, in a one-piece bathing suit, with her arms and legs spread out as wide as they could go, on plush green

grass, rain pouring down on her with her face radiating pure, unbridled joy. Across her waist, in the photo, were the words "REMEMBER HER?" and lower, across her shins: "She is still there... inside you... waiting... let's go get her." "This picture reminds me of who I was and how I want to feel. Take me there," I said.

channeling

ast month, I flew to Arizona to attend the Genius
Network's annual conference in Scottsdale, where 250 of
the world's most inspiring entrepreneurs were looking to
connect and collaborate with like-minded people. Wanting
to get out of my real estate box, I plunked down $10,000
to attend this annual meeting. If I liked the meeting, an
additional $15,000 granted me admission into this exclusive
business group for the next 365 days.

At breakfast on the last day of the conference, I was sit-
ting around a table amongst many new faces. A stunning
thirty-something-year-old woman with a bleached white
pixie cut and piercing blue eyes sat down at my table. I leaned
in, intrigued. Anyone with the courage to own that hairstyle
rocks in my world. "I channel books," Keira said to everyone
and to no one. At this, I leaned in even more.

Given the stack of healing stone bracelets adorning her wrist and the large mood ring on her left index finger, this statement should not have surprised me.

"Tell me more," I said to Keira from across the table.

I was raised by a strict Catholic mother but had read many books on spirituality, angels, and souls. I knew what spirit guides were, had read Ester Hicks' books about her channeling of Abraham, and had watched television shows where psychics connected with the deceased who had messages to share with family left behind.

"I help creators get unblocked when they are writing. I channel their messages through published books. Books talk to me," Keira explained.

"You had me at channeling," I said cheesily to Keira across the table just as a buffet staffer rang the bell, signaling breakfast was over.

Back at home in Florida a few days later, I was in my home office on a Zoom call with Keira.

"Close your eyes with me," she said. "We are going to do the sacred creative process. I want you to take a deep breath in. Let's create clean energy and safety to receive more. A pocket of light is around you, around me. *Ahhhh*, breathing in that sound, regulating our nervous system. Take a deep breath in with me. We are going to pour this beautiful light into the crown of our heads and cleanse the body; anything that is not ours, we are going to breathe out through the soles of our feet. After we bring in the divine light and have access to our divine gifts, we will call in our spiritual team. Our angels, our guides, those that are here to support your book."

Then silence. My eyes were still closed, and I was not sure what to do. After a few more minutes of dead air, Keira spoke softly.

"I see a closet stuffed with clothing packed so tight it's hard to slide the hangers in either direction. Someone is in the closet pushing back clothing to create a narrow opening. Through this opening, I see the most beautiful outfit, hidden in the deep recesses of the closet, behind all the other clothing. What does this mean to you?" she asked me after a pause.

I was wondering the same thing and was not sure what to say. I asked her for a moment to think and closed my eyes, trying to call my spirit guides forward, something I had never done but was open to trying. "What does this closet mean?" I contemplated and waited for something, anything, to happen.

To my surprise, an image slowly emerged. I saw myself with Maria, my daughter. We were standing at a red brick colonial about to ring the doorbell. I'd been here before. It was Rachel's house—Rachel, the House of Color image consultant I'd visited the year before, who helped me discover my season and style of clothing that made me feel most like me.

I explained to Keira why I went to see Rachel and how discovering that I was a "Winter" who felt best in natural-romantic-style clothing had resulted in me feeling more integrous over the past year.

"Fantastic! This is great," Keira exclaimed. "Now, Betsy, what is your book about?"

Like the beautiful outfit hidden in the back of the closet, I told Keira about my struggle with the many invisible boxes I found myself in that filled me with rage and often obscured the real me.

"I love it. How far along are you in your book?" Keira said.

"I'm only seventy pages in. I need to get to two hundred," I said. "Structure-wise, the book is laid out with before, middle, and after stories, and I need a few more of each to be able to finish." Looking for inspiration, I continued, "What should I do?"

Like a traffic cop, Keira abruptly put her hand up to her computer screen as though we were reading palms. "STOP," she said. "I'm getting a vision of a dam between your heart and your brain, behind which your stories are backed up. You are writing a book about getting out of boxes, but you have put yourself in a box in your process of writing it. Who says your book must be two hundred pages? It's as long or as short as it needs to be. You cannot put an arbitrary stop to your spirit. When it's done, it's done. And why does it have to have a structured beginning, middle, and end? Whose rules are these? A book to you is different than a book to me."

She continued, "What do you want your book to look like? Do you want your pages to have pictures on them, quotes, writing prompts for the reader? Step outside the box of what you believe a book is, and your stories will flow."

Like a sweet melody, I loved hearing these words. That evening, I went into my bathroom, parted my hair down the middle, and put it up in high pigtails for the first time since I was eight years old. I opened my jewelry drawer and slipped on my tarnished brass ring engraved with "*All is well within my soul.*" I sat down at my computer, rubbed lemongrass oil between my palms, closed my eyes, and breathed in deeply, calling on my angels and spirit guides to assist me. I set my fingers on the keyboard and watched them fly ferociously over the keys like a master pianist, the dam broken by stories pleading to be released.

choose me

I grew up with parents who worshiped education and book knowledge. I am tremendously grateful to have had role models who supported my classroom learning; much of my success is because of their hard work putting me through school. In our home, knowledge ruled, and feelings were discounted. While I aced my spelling tests, my treasure chest of emotional vocabulary was limited to four words—good, bad, happy, or sad. "What do you think?" was a question I was asked frequently, while "How do you feel?" had never been uttered in my direction.

Second-generation immigrants, my dedicated parents drilled into my sisters and me at a young age that we'd be getting a higher education. A bachelor's degree just wouldn't cut it. "The one thing that can never be taken from you is your education, so you best get a lot of it" was a philosophy instilled in me from the time I was a toddler. Every family

has a currency. Our family measured value by grades, class rank, and diplomas, without which you were worthless. This, I'm sure, they learned from their parents and, hence, it was natural for them to pass it down.

Fortunately, my sisters and I excelled at school, and my parents were both very proud and involved. Mom checked our English papers for grammar and added our doing well on exams and the SAT to her prayer list while Dad quizzed us after dinner before every science and math test, sending us back to our bedrooms to study if he felt we didn't know the subject material well enough.

Every six weeks, I excitedly waited for report cards to be sent home so we could go to Pizza Hut to celebrate. My goal was to leave high school, not having taken classes that interested me but with a GPA high enough to get me into a top college. My twin sister got straight As, graduating first in our large public high school class, along with two other students with a perfect GPA. My B+ in social studies junior year dragged me down to salutatorian.

After high school, my sisters and I attended Duke University, and the three of us enrolled as pre-med. My older sister was a junior when my twin and I were freshmen. We all planned to major in psychology because, as Dad said, it's still considered a science but gives you a break from the other hard science classes we'd have to take in medical school.

Two years passed, and my older sister, Marci, graduated from Duke and returned to Florida to attend medical school at the university where my father practices. As a junior, I had to formally declare my major to my academic adviser. This would be a piece of cake, as I'd never been so sure of anything in my life. What had me in a tizzy was having to declare this to my parents. I had been dreading this day since I first applied to Duke.

When I started college, I was not sure I wanted to be pre-med, but it was expected of me, so I registered pre-med, knowing I could change my mind. Two years later, I knew with conviction I didn't want to go pre-med. With ZERO interest in the science classes I was required to take, I found them difficult and dull. I got headaches from the rote memorization required to pass the exams and would forget everything I learned within a week of taking a test. I also despised having to work for physicians in the hospital where my father worked during my high school summers. It was dark and depressing, and the days were mind-numbingly routine.

Now entering my third year of college, I was taking business classes sprinkled in among my pre-med classes. It was in these classes that I felt alive. Time would stop as a freeing and exciting energy overtook me the minute I walked through the classroom door, reminding me of feelings I had discovered during the entrepreneurial adventures of my youth.

When I was eight, I started clipping coupons and negotiated a sweet deal with my mother. Mom would pay me the value of the coupon redeemed if I put half the money in my piggy bank for college. I quickly became the Coupon Queen and took my title seriously, signing up for coupon clubs around the country. I'd mail yellow manila envelopes stuffed full of coupons and rebate offers for products my family would never buy in exchange for ones we did purchase. I insisted on going grocery shopping with my mom and waited patiently for the S&H Green Stamps to spit out of the silver slot machine after the cashier rang up our total at the Publix checkout counter.

I'd carry the stamps home proudly, lick their backs, and press them onto the pages of a Quick Saver Book immediately after getting home. Like Marcia and Greg of *The*

Brady Bunch, who wanted to get a boat and sewing machine with their Green Stamps, I'd pore over the S&H Ideabook, mesmerized by all the things I could buy with mine. One- and three-quarter books would get me the 12 Colony "Whitehall" Water set my mom liked, but for only three books, the hot pink shower curtain ensemble I coveted could be mine. Once I decided what I wanted, Mom took me to the S&H store to trade in my filled books for the navy blue sleeping bag we used on future camping trips or the lime green blanket with the smooth satin edges I loved, which I may or may not still have.

I was also known in my youth for my early Saturday morning garage sales, pulling out the patio benches and tables to display our family's discarded wares along the perimeter of our wide driveway. I'd spent the previous week meticulously pricing each item only to learn the fine art of negotiating over twenty-five cents. After years of strangers coming up our driveway with flashlights in the dark, peeking into our garage before we were open, or asking to use our bathroom, my father put a stop to my business enterprise, banning me from holding any future garage sales.

In high school, I took a cake decorating class at the local community college and started selling homemade decorated baked goods. I also schemed to buy cases of M&M candies and Snickers bars from the Sam's Club my mother frequented, only to turn around and sell the candy to students at my high school at a 100 percent markup like the band kids did. My high school was huge. Who would know I wasn't in the band?

Before entering my junior year at Duke, I worked for Merrill Lynch in the summer. The president of the branch, Scott, had an assistant going on maternity leave and told my mother he needed help. Although the job was administrative,

Scott taught me about stocks and options and even allowed me to open my own trade account despite being under twenty-one years of age. I began trading, selling, and buying calls and puts during my lunch break. I worked for free that summer, but the experience I gained was priceless.

Now, in my junior year at Duke, with a few business classes under my belt, I found discussing the four Ps of marketing more interesting than memorizing the elements in the periodic table or dissecting a fetal pig. How in the world would I break this news to my parents?

A little bit of background: My parents' world is medicine, and being a physician is *revered* in my family. And that is really an understatement. My mother worked to put my dad through medical school and since then, he, a cardiologist, stands second in line behind God in my mother's eyes. There is no one worshiped more than my father in our home. There is no more esteemed profession, no higher calling, no taller pedestal upon which one could perch. My parents told us we could be one of three things: a physician or lawyer, and if we can't be one of those, an engineer as a last resort. They only wanted the best for us, and they believed these professions were the best.

With this background, I had to muster up the courage to call my parents and let them know I was going to disgrace them. I called them from the hall phone in my dormitory.

"Can you get Dad on the phone too?" I asked when Mom picked up the phone.

"What's up, Betsy?" my dad said in his calm, monotone voice when he picked up the line.

"I have something I need to tell you."

My body was boiling, as it always does when I get nervous. Sweat rolled down the inside of my arm. I inhaled deeply.

"I'm calling to let you know that I'm getting out of the pre-med track so I can major in economics instead."

Wanting to fill the silence on the line, I babbled on. "Economics is the only business major offered here at Duke, and I really like business, so I'm going to meet my adviser tomorrow and make the change."

More silence. I counted slowly and silently to ten.

"Mom, Dad, are you there?"

"Yes, we are still here."

I squeezed my eyes shut. "There is just one more thing I should mention. I'm not going to graduate school right after college." I raced to get the words out. "Top business schools require students to have work experience first, so I'll be getting a job after college."

"Okay, Betsy." My mother cleared her throat. "We think you are being irresponsible, and if you think you are going to want to go back to school once you are out working in the real world, you're nuts." While I understood that many students fail to go back to school once out, I was disappointed in her lack of faith in my commitment to education.

While I desperately wanted to push the Eject button in this conversation, I also felt a strange momentary sense of peace—two feelings that are often precursors to busting out of boxes. "I understand you are disappointed. I know you wanted me to be a physician, but I must do this. I must do this for myself. I won't be happy otherwise."

"It looks like you've made up your mind. Just so we are clear, Betsy, you will be on your own financially the day you graduate from college. We don't support children who aren't in school," my mom said.

"Yes, Mom. I understand," I replied.

I hung up the phone utterly exhausted—until then, I hadn't realized the amount of mental energy required to choose my desires over theirs.

For months afterward, I struggled with my decision and, even more, with my worth. I was on the dean's list at a great school. I held three part-time jobs to earn spending money. I didn't drink or do drugs. I'd never been in trouble with the law. Yet I was a failure in my parents' eyes. Whenever I veered outside their narrow box of expectations, love felt withheld. When I stayed inside, I was like a dog praised for going into its crate.

dancer

When my girls were in high school, one evening, we had just finished dinner around my parents' dining room table when my mom asked my older daughter, Maria, what she'd like to do after college. I already knew the answer. Considered a late start in the dance world, Maria began taking dance classes in ninth grade. She had natural talent, and she quickly rose to the top of her dance company. She planned on majoring in dance in college and going on to dance professionally, either on Broadway or with a major dance company.

My daughter beamed at her grandmother. "My dream is to be a dancer."

My mother laughed and touched Maria's arm. "No, really, Maria, what do you want to be?"

The color drained from Maria's face. She looked at me, then back at my mom, then back to me. I felt heat rise within me. From the day they were born, I had encouraged my daughters to follow their passion and instilled in

them the belief they could do anything they wanted. I had shielded them from the limiting beliefs drilled into me when I was a kid and from a mindset that only certain professions were deemed acceptable. My parents never viewed any form of creative expression as a viable profession but rather as something you did outside of your main line of work for relaxation. It was like the side dish to the entrée, something that balanced out the meal or your life.

"No, really, I want to be a dancer," Maria said.

"You can dance in your spare time, but you need to have a real career," my mother said.

"Mom," I said, "Maria wants to dance. There is no reason she can't be a dancer. Don't tell my children what they can and can't be. They can be and do whatever they put their minds to. I did not raise them the way you raised me."

For so long, I had protected my girls against the limiting beliefs on which I had been raised, fighting to raise strong, independent girls who could do as their hearts desired. I was trying desperately to create a supportive environment where they were free to choose what they wanted to do with their lives. Yet, somehow, I had failed to anticipate this conversation with my parents and, hence, never expressed my opinion about this to them before this evening.

The conversation disturbed me, and we left my parents' home shortly afterward. When my girls and I got in the car, I reiterated they could do and be whatever they wanted. Nothing was off-limits or unacceptable. The most important thing was to find something they were passionate about because then it would never feel like they were working.

I looked at them in the rear-view mirror and saw two faces looking as if they had just been told there was no Santa Claus. The seed of doubt had been planted and already taken root when minutes before there had been none.

box of chocolates

I was thirty-three years old and had been working in the pharmaceutical industry since graduate school. Recently divorced, I moved back to Florida to be closer to family to raise my daughters. I worked remotely in the marketing department of a biotechnology company. Our one and only product, touted as the cure for the common cold, unexpectedly did not receive FDA approval, so the company closed its commercial division, the division in which I was working.

Fortunately, I had built solid relationships within the pharmaceutical industry, so was able to scrape together enough freelance consulting work to keep my daughters and me afloat financially while I figured out a game plan. Although this consulting allowed me to work from home, the schedule was taxing, and I was growing increasingly uncomfortable with being so geographically remote from my clients in the northeast part of the country. I knew I didn't

want to move back to the Northeast—I greatly valued being near family and seeing my children build strong relationships with their grandparents on both sides.

After evaluating all my local employment options, taking a secure job working for the large healthcare center in town seemed the most logical thing to pursue. This would provide health benefits for my daughters and me and the security of a biweekly paycheck. However, I had volunteered at this institution as a teenager during summer breaks and hated it. It was one of the (many) reasons I wasn't a physician. I didn't like working inside a huge windowless brick building day in and day out. When I worked there during summers, I never knew what the weather was or saw the sun, and I found that adversely affected my spirit.

Now, years later, I knew I needed to spend some part of each day in the sun to feel healthy and alive. I also didn't like the predictability and mundane nature of an office job. Routine makes me uneasy. Plus, during my months of contemplation, I realized I never cared for working for someone else. I had worked for bosses I didn't respect, bosses who were demeaning, bosses who yelled, and bosses who were sexist. I also didn't like someone else deciding how much my time was worth or renting out my most valuable asset—my time. Other than security, the option of working at the large healthcare center held little appeal and would certainly not make my heart sing.

Still undecided, I made a list of things I both enjoyed doing and excelled at. I assessed what I truly loved to do— things that made time stand still. Business had always been a calling. Since I was a child, I've been fascinated, not by money itself, but by the process of making money. I was an entrepreneur at heart right from the start. I also knew I loved real estate. While studying for my MBA at The Wharton

School of Business, I took a class on rehabbing homes. Every Saturday morning, the class would meet at a dilapidated row house, and we'd spend the day renovating it. We gutted the interior and rebuilt it using donated materials and labor. I loved getting my hands dirty and seeing the weekly progress. After a house was done, we interviewed financially challenged families and sold the house to them at cost. Being involved in this experience and seeing how home ownership could alter the trajectory of a family was life-changing for me.

Now, twelve years later, contemplating my next career move, I reflected on that time at Wharton and how I loved real estate. Having recently bought two rental houses near my home, I was enjoying managing the properties myself. I found myself planning my daily run for exercise around nearby housing developments under construction so I could watch the progress of neighborhoods being built up around me. And because I was raised in the community and was raising my girls here, I could be an asset in helping others move to and from my hometown. I thought I could do this through real estate.

Having made the decision to get my license and become a real estate agent, I was now faced with how to tell my parents. They had long recovered from my decision to not be a physician and not go to graduate school straight out of college. But could I risk disappointing them again? They had worked so hard to put me through some of the top schools in the country so I could be a highly esteemed professional. How could I tell Mom and Dad I was going to embark on a career where a GED and a one-week class earns you a license? As the black sheep of the family, I owned this role but still dreaded the conversation.

One night around my parents' dining room table, having just polished off Mom's scrumptious gingerbread, I went for it. "The travel my consulting requires is wearing on me, and with the girls still in school, I need to make a change."

My parents, sitting at the opposite heads of their rectangular table, stared at me.

"I've decided I'm going to get my real estate license and start selling houses."

Deafening silence filled the air. My girls, ages seven and eight, knew enough to remain as quiet as mice. I wanted to frantically search for the eject button on the side of my chair to remove myself from this scene.

My parents' smiles quickly flatlined. After a long pause, my mom said, "That's great, honey. I'm happy for you."

Relieved, I let out a big sigh.

"But," she said, "while your father and I support your decision to go into real estate, please know you will not be our Realtor. We already have an agent we like."

I felt whiplash from the invisible slap in the face.

"But, Mom, you haven't bought a house in years. You'd use someone else over your own daughter?"

"Yes, we would."

"Why would you still feel obligated to use her now if I got my license?" I asked incredulously.

"Because, Betsy, every Christmas, she sends us a box of chocolates."

I had been staying within the lines since I learned how to color in elementary school. This propensity to do what was expected of me initially kept me safe, assuring my parents' approval. It served me until I was thirty-seven, and woke up feeling life passing me by. I started to question whose life I had been living. I had never asked myself, "What do I want? What makes my heart sing?" I always did what was expected

of me, what I "should" be doing. I had been living in a haze, a plane on autopilot.

This conversation shifted something deep within me. No longer needing my parents' approval, I was not going to let a box of chocolates get in the way of a new life.

houses

After living in Florida and raising my daughters in the same house for over a decade, I decided to move in 2011. While our cozy abode was adequate, the footprint began to cramp us as my daughters were getting older, and we had added a beloved rescue dog, Dakota, to our family.

After months of meticulous searching on the multiple listing service and also seeking out hidden inventory, I found the perfect house. It was a local builder's sales model in a luxury community on the outskirts of town. The house sat on a large, spacious, meticulously manicured corner lot across the street from the community pool and a gated 10-acre lake where Dakota could run free.

I knew the minute I stepped inside that I was going to buy this house. At the time, I was starting to build my real estate brokerage and wanted space for an assistant to work with me in my house while I kept an eye on my daughters.

The builder of the house had converted the three-car garage into a working sales center. The space was designed exactly how I had envisioned for my budding real estate business.

We moved in a few months later. Arriving at the house for the first time, only minutes ahead of the moving van, my daughters couldn't stop running through the house exploring all the new rooms. At almost 5,000 square feet, it was over twice the size of our prior home, and my daughters scrambled to claim their respective wings. Maria took the large bedroom in the back corner directly across from the expansive, darkly lit movie theater room and beside a spacious full bathroom she wouldn't have to share. Elena planted her stake in the en suite upstairs, complete with her own screened balcony and private set of stairs. Dakota happily found her bed in the corner of our soaring two-story family room.

As I started unpacking boxes, I pulled out a vision board I had made four years earlier. I remembered cutting out the picture of a sharply dressed, put-together businesswoman when I decided I wanted to be a broker. This woman had been featured in a magazine for her successful real estate brokerage, and she was photographed in the new house she had renovated, one surprisingly similar to the home I now call my own. Having forgotten about this vision board, I realized I had manifested my vision and felt like I had finally "arrived." This house was my physical proof.

A few years went by, and my business was bursting beyond the walls of our home. I added several agents and a marketing assistant, so I moved the business into office space purchased from a neighbor. My girls were now approaching the end of high school, and I sensed myself growing

increasingly unsettled. The time with my girls at home was running short, and I was feeling emotionally and physically distant from them and myself. While I was sure some of this had to do with their ages and growing need for independence, I also felt our house contributed to this distant feeling.

While I had never said this out loud, my inner voice had been telling me our house had never felt like home. It worked well for my business, but it was hard to make a 5,000-square-foot house with 20-foot ceilings feel cozy and intimate. Having to text my daughters to know if they were in the house with me did not feel intimate. With eight entrances and exits, we came and went, often not knowing who was where when. The sprawling floor plan offered few opportunities for the spontaneous collisions and conversations I had taken for granted in our smaller home. Over the moon when I bought this house; what I had thought was important was not. I was the local expert in residential real estate, a broker of the American dream, but somehow, this "dream" felt anything but.

Our previous home, at 2,000 square feet, was beckoning to me. I typed our old address into Zillow.com to see if it was for sale. It was not. I called the owner, asking if perhaps they'd be interested in selling it back to me. "No," I heard on the other end of the line.

Over the next several months, I scoured the multiple listing service for anything that might feel like home to us. I toured countless homes, but none felt right. My quest for a new home started to feel urgent. Maria was about to leave for college, and Elena was finishing up eleventh grade. I did not

want to be in this ginormous house by myself when both girls were away at college.

I called my twin sister, lamenting my predicament. I was a top Realtor but couldn't find my own next house. "I just wish Grandma's house would come up for sale."

My father is an only child, and his mother, my grandmother, had been in a serious car accident when I was young. She was the primary caretaker of my grandfather, who had been partially paralyzed from a stroke when I was two. After my grandma's car accident, my father decided it was time for his parents to be closer to him, so they bought the vacant lot next door to us and built their forever home. In our backyards, we poured a concrete sidewalk connecting our two homes so my grandfather could maneuver his wheelchair using the sidewalk for visits and to do his daily physical therapy in our outdoor pool. It was a dream to be able to skip over to my grandparents' house to get a whiff of the homemade peach pie coming out of the oven.

Decades later, after my grandparents both peacefully passed away in their beloved home, we sold my grandparents' house to an incoming professor at the University of Florida. Now, I longed to move into their old home. The morning after my conversation with my twin, my cell phone rang. It was a seller wanting me to list his house.

"Sure, I'd be happy to help. What is your name and address?"

"Betsy, this is Juan Carlos."

"Juan Carlos? Juan Carlos, the man we sold my grandma's house to in 2001?"

"Yes, that's me."

I was stunned. I opened my mouth to speak but heard no words. I shut my mouth, opened it, and tried again to speak.

"Hello? Betsy? Are you there?"

"Yes, yes. I'm here. I'm just… well, surprised really to hear from you."

At that moment, I forgot all my hard-earned negotiation skills.

"Juan Carlos," I said. "I don't want to list your house; I want to buy it."

I ended our call quickly to rush to my computer, pulled up a blank purchase and sale agreement, and started typing in the free-form fields.

Buyer: _____

I typed Elizabeth Pepine, my legal name.

I paused in wonder. How ironic.

I was named after my grandma. Elizabeth Pepine is buying Elizabeth Pepine's house. I could hardly type; I was so pumped with adrenaline. Once finished, I printed my offer and scrambled to my car, panicking that Juan Carlos would change his mind before I reached his house.

Twenty minutes later, I pulled into my grandma's driveway. I had not been in her house since we sold it to Juan Carlos. I parked my car and walked up the sidewalk. A sudden flood of memories rushed in. I saw myself wheeling my grandfather up the red brick ramp leading to the front door after taking him to his favorite restaurant, Long John Silver's. I could envision the homemade Christmas wreath made out of white yarn wrapped around a large cardboard wheel, with upside-down red Solo cups for bells that once adorned the dark solid wood front door that I now stood in front of.

Before I could ring the doorbell, Juan Carlos greeted me at the door.

"It's been a long time, Betsy."

"Fifteen years. It has flown by."

"Come on in, and I'll show you around."

In the foyer, I reminisced about Sunday afternoons making ravioli with Grams and her 1980s beige KitchenAid mixer which adorns my kitchen today. Looking past the foyer, I saw the family room where my grandparents sat, side by side, every afternoon in their recliners, watching Judge Wapner rule on *The People's Court* before dinner. I caught a glimpse of the dining room where Pappap would play bridge with his church friends who would come visit him.

"No, Juan Carlos. I don't need to see the house," I said, forgoing all negotiation leverage. "I want this house back in the family."

Juan Carlos smiled.

"I'll waive the inspection," I said. "Heck, I'll waive the survey too. We can close tomorrow if you want."

"I need to stay until my students are out at the end of May."

I had just flipped my wall calendar to March. "No problem; stay as long as you like. I'm in no hurry."

To seal the deal, I offered a price 15 percent higher than the highest comparable I could find. I did not want this house to go on the market.

"This all sounds too good to be true," Juan Carlos said.

It was. But I hadn't ever wanted something so badly, and I had seen houses slip out from buyers' hands over the littlest and silliest of things.

"Betsy, just give me a day to think about it. I want to run all this by another Realtor."

My eyes widened, my eyeballs straining from their sockets. Twice in a day, I was at a loss for words. I'd given him everything he'd asked for and beyond. I'd purposely offered a price so high there was no way he could question the value or my motive. I waived all contingencies, even the inspection, something I warn buyers never to do. I was letting him

post-occupy the house for free until he was ready to move but closing early so he could have the money to buy where he was moving.

There was nothing more I could do. Now, I had to wait and hope the universe and I were aligned.

"Thank you, Juan Carlos. I appreciate you calling me and I hope you see how my offer allows you to make your next transition stress-free."

A painstakingly silent and long twenty-four hours went by before Juan Carlos called.

"My real estate agent says your offer is too good to pass up. He recommends I accept your offer. Besides, I'd like to see the house back in your family."

That was truly one of the happiest moments in my life. I'd never felt such peace.

We moved into my grandma's home six months later. Within ten minutes of unpacking, Elena said to me, "This feels like home." We had downsized from an almost 5,000-square-foot, five-bedroom, five-bathroom house to a small 1,600-square-foot, three-bedroom, two-bath home. Several friends who have since come by have told me this home feels so cozy and warm, unlike my previous house. Nothing had ever felt so right.

I had lived in a spacious "picture perfect" house by magazine standards, but now I live in a cozy home. It's small enough to use every room every day. I always know who is in my house. I never have to shout to someone across the house for them to hear me. My dining room table and kitchen table are one and the same. If someone drops a fork, I can reach the utensil drawer without getting up. I love that the rooms

are so close together that I can no longer get my daily steps in just doing the laundry.

I thought I had wanted the big dream house, but after I had it, I realized, like the Rolex, that box was never meant for me.

awards

After four years of working as a sales associate in real estate, I became a broker and went out on my own. I had no real goal of building a company. I happily worked from a desk in the living room with my girls, now ten and eleven, acting as my fulfillment center. After casting their votes on my company logo, they would spend their free time earning money affixing address labels to my mailers and stuffing hundreds of colorful plastic Easter eggs for the community egg hunt I hosted for the neighborhood. My first hire was a marketing expert whose efforts yielded additional sales for me to service. Meanwhile, every few months, an agent would ask if they could join me. Promising them nothing but a desk, people started showing up at our house daily. We moved into a bigger home so I could work from home but have enough space so that my business did not physically encroach on our family life. My second hire was an administrative assistant

to handle the mounds of paperwork my growing enterprise produced. A few years went by and having taken no significant time off, I felt overwhelmed. My girls and I needed a break, so I booked a cruise. Having only been on one, the idea of being digitally disconnected was appealing. Two days before embarking, my administrative assistant asked to meet. Thinking she wanted to discuss how the workflow would be handled while I was away, I jotted down a few notes and met with her.

"Thanks for meeting with me. This is new to me."

"No problem, Kelly. I know you've never had to hold down the fort on your own, but it will be fine." I pulled out one of the charts I had sketched out.

"Umm… I need to tell you something. Please don't be mad."

"Oh. Okay. What is it? How can I help you?"

"Umm. I'm quitting."

I stared at Kelly, confused. "What do you mean? I thought you were happy here. You are doing so well." I had worked with Kelly at a prior real estate office years before, and when she moved back to town, she reached out to me, desperate for a job.

"I am happy here, but I need something different."

"Okay. Help me understand so I can learn from this."

"The work here is fine. It's just there's no room for advancement. I have no place to grow."

I couldn't argue with her. We were a small company with two employees.

"And there's one more thing. We don't have any opportunities to volunteer or serve the community outside of helping them buy or sell a house. The company I'm going to offers countless opportunities for me to get involved with the community. I really want that, and it's missing here."

This comment stopped me in my tracks. Outside of work, I had spent hours upon hours volunteering in the community—raising seeing-eye dogs, feeding the homeless, volunteering at food banks, sewing for indigenous tribes in Africa, fundraising for charities, and serving on nonprofit boards. But it never occurred to me to include agents and staff in these initiatives. These activities were very siloed in my life, in how I was raised and the box I put "work" in. You go to work, you work, and you come home. Once you are home, you pursue your non-work hobbies, interests, and service. Your employer didn't get involved in your life outside your work. The line was very clear. But Kelly was telling me she wanted those lines blurred. She wanted to work for a company that provided more than just a job and a paycheck. I had blindly put my company in the box that prior jobs had modeled for me. Hence, my company provided people with a job and a paycheck. Nothing more. Nothing less. And in return, they gave me their time.

That night, instead of packing for our cruise, I poured over books in the business section at Barnes & Noble and lugged home a bag of ideas on how to build a great culture. I spent the cruise devouring ideas from companies that had created great cultures, companies like Zappos, Google, Apple, Starbucks, and Facebook. I took copious notes and came back filled with inspiration, excited to turn my company on its head.

Upon my return, I created a set of core values that I wanted our company to espouse, values such as integrity, accountability, excellence, family, fun, balance, growth, and impact.

Within months, we arranged regular outings to volunteer as a group. We painted horse stalls for an equestrian rescue, we served dinners to homeless families, we fundraised for the American Heart Association and did their 5K walk together, and we organized Petoberfest, a Halloween parade for animal lovers. We even created a nonprofit, Pepine Gives, that helps provide safe and affordable housing to cost-burdened families.

Years later, agents and employees who work for me are very active in the community. Staff volunteer during working hours and get paid to do so. I pay agents and staff to attend conferences to learn new skills in life or business; I offer a finance class to show them how to manage their money and get out of debt; I pay for a pension plan unheard of in our industry. I match charitable donations and organize volunteering opportunities for all. Locally, our efforts were recognized with Business in Gainesville giving us The Impact Award and the community voting us Best of the Best Real Estate Brokerage. We were also recognized at the state level receiving the Florida Trend Best Companies to Work For award and named a Top 50 Florida Company to Watch. While I lost a great employee, dismantling the box of what I viewed my company to be changed the trajectory of it.

categories

As my company grew, I applied to be in *Leadership Gainesville*, the aforementioned leadership and professional development training program offered by our local Chamber of Commerce. I wanted to collaborate with other business owners and leaders and learn from the best. I was accepted into the program and became more involved in both the community and the Chamber of Commerce. I joined a few of the chamber committees and attended numerous events the chamber hosted.

A few years later, I was invited to the chamber's end-of-year awards banquet. There, I got to network with the top business owners in our community. When I got home from the ceremony that evening, I was exhausted yet exhilarated. I turned on my computer, googled the event, printed out a picture of the award winners, and placed it prominently on my vision board.

I attended the awards ceremonies for the next two years and then mustered up the courage to enter my company for this prestigious award. When I downloaded the application, I saw the following:

Check all award categories you'd like to be considered for:

☐ Startup Business of the Year
☐ Tech Company of the Year
☐ Manufacturing Company of the Year
☐ Nonprofit of the Year
☐ Leading Women's Enterprise*
☐ Small Business of the Year
☐ Large Business of the Year

I hadn't realized there were so many categories, most of which didn't apply to me or my company. I knew Large Business of the Year was the most coveted award, and our sales and personnel count qualified us. I reread the list. When I got to ☐ Leading Women's Enterprise*, I wondered what exactly this award was for. The asterisk stated, *majority share of company is female-owned. I reread the list. Where was ☐ Leading Men's Enterprise? This irked me, and I wasn't sure what to do. I'd worked hard building my company and really wanted it recognized, but would I be okay winning something based on my gender? I reasoned that maybe if I won, I would be a role model for up-and-coming female entrepreneurs, and that would outweigh the dissatisfaction I had over the chosen categories. I checked two boxes: Leading Women's Enterprise and Large Business of the Year.

A few months later, I invited the agents and staff who had been with me the longest to the awards ceremony. I was feeling really hopeful about our chances of winning and was so nervous about the speech I'd have to give if we won that I could barely eat. After dinner, the emcee started announcing the award winners.

"Leading Women's Enterprise goes to... Eat the 80!" he said.

While disappointed, I let it go. We still had the main award, the one I really wanted.

"And the Large Business of the Year award goes to... Gainesville Health & Fitness and owner Joe Cirulli."

Joe and I are friends. This award was well deserved. His business is legendary in our town and he has contributed so much to our community. Joe had always been a mentor to me, and I was happy for him. I hadn't realized I was competing with such high talent.

The next day, I replaced the picture of the prior year's chamber award winners on my vision board with a picture of Joe holding the Large Business of the Year award plaque he received.

With newfound determination, I worked tirelessly the next year, focusing more on our culture and community. I sent the application I had submitted to past voting panels, asking for feedback on how to improve it. I got better at documenting our culture with pictures and video and quantifying the impact we were having on the community by logging volunteer hours and lives impacted.

In the fall of the next year, I was facing the checkboxes again.

☐ Leading Women's Enterprise*
☐ Large Business of the Year

I still didn't agree with having a women-only category if there wasn't a corresponding men's category. What message was that sending? It implied women need their own category because they can't compete in the "main category" open to both men and women. I didn't and don't want to win on a technicality or a vagina. I checked only one box—Large Business of the Year—held my breath and clicked Submit.

A few days later, someone from the chamber called asking if I had forgotten to check the Leading Women's Enterprise box.

"No, that was not a mistake," I said. "Please do not consider me for that category."

"Are you sure? You'd be a shoo-in."

"Yes, I am sure."

Two months later, I invited my team back to the awards ceremony. It was risky to get my hopes up, but I knew I'd rather go home empty-handed than win in a gender-specific category.

Toward the end of the evening, I heard: "And the Large Business of the Year award goes to... Pepine Realty."

While the 250 people in the room didn't know I had eschewed the gender box, in my own way, I had advanced the plight of women that night.

holiday

As a writer, I'm fascinated by words. A word is a string of innocuous letters put together in a certain order. People begin to use this string of letters and it slowly falls into mainstream usage. With greater adoption, the word is added to our dictionaries and taught to our children.

It's interesting how two people can see the exact same word and see something totally different. A word we deem highly offensive means nothing to a culture unfamiliar with the language, even though it can evoke strong emotions in those familiar with the language.

Languages evolve, new words are added, and the definitions of words change over time. In some dictionaries, "woman" now refers to both adults who were assigned female at birth and to adults who identify as female.

In the life cycle of a word, it can start out as being useful and benign, but, over time, a word can take on a harmful

meaning, and its usage falls out of favor, is banned, or even retired from dictionaries. In real estate, we no longer describe the largest bedroom of a house as the master bedroom. It's the primary bedroom. Plantation shutters are just shutters or wood shutters. A butler's pantry is a second prep area. I know how viscerally charged I feel when I hear certain words that demean women, and I gladly removed words from my vernacular that referenced a time when people were put in invisible and very inhumane boxes.

The invisible boxes we find ourselves in are often defined by, reinforced, and passed along with words. Words label. They are used to describe expectations of what something is. The minute you hear the word "holidays," what do you think of?

A dear friend and single mother has one adult child who lives across the country. With little extended family, holidays had become lonely and less joyful when they didn't live up to the expectations she saw described in the media. This year, my friend decided to redefine what the word "Thanksgiving" means. Maybe it's not the image of a big family around a table filled with food we are inundated with. Maybe it's a vacation to a place she's never been. Or a day riding her horse, enjoying the quietness on her farm. Another friend, also divorced, raised her children to believe "Christmas" was not the date of December 25 but rather a time in December that they celebrated family with laughter and fun and presents. That day could be the twentieth or the twenty-eighth, depending on when they could all be together. Relaxing the definitions of the holidays we've come to know opens up a world of opportunity to enjoy these days with more joy and less disappointment.

travel

A few years ago, I was in New York City in the makeup chair, preparing to shoot a commercial with my mentor, *Shark Tank*'s Barbara Corcoran. The makeup artist on set, Zann Parker, was a petite ball of fire, about a decade younger than me. Her energy was infectious, which was my cue to start asking questions.

"What makes your heart sing?"

"Africa."

Zann now had my full attention. I'd had a picture of a giraffe in the Serengeti on my vision board for years. I love animals and feel most at home surrounded by them. To see the Big Five (lion, leopard, elephant, rhino, and African buffalo) in their natural habitat was a huge bucket list item for me. "Tell me more."

While filling in my brows and contouring my face, Zann described her true passion—yearly trips to Africa to visit local Ethiopian and Sudanese tribes, where she lives amongst

the people and learns their way of village life. She videos her travels and uses them to spread awareness and educate others about these tribes through her YouTube channel. She said she works in makeup in New York City only to earn money for her next trip to Africa.

When I moved from Zann's makeup chair to the hairstylist, I looked up her YouTube channel and watched one of her videos. It showcased her dancing with village children, helping women cook, and socializing with indigenous families in their huts. My quest to visit Africa catapulted to the top of my desires. After the stylist was done with my hair, I sneaked back into the makeup room.

"Zann, I forgot to ask, who do you travel with?"

She laughed. "Oh, I always go alone."

"Really? You go to Africa by yourself?"

"Yes. I wouldn't have it any other way."

I felt like I always do when I meet someone ten steps ahead of where I am currently in life. Invincible and on Cloud 9.

When I had envisioned my trip to Africa, I never considered going by myself. In my life, vacations had been in a box defined by going away with family and friends. Random thoughts raced through my head. Who vacations by themselves? And the thought of going that far away alone scared me due to my fear of flying. Could I handle being over a ginormous body of water on a plane at a cruising altitude of 42,000 feet for fifteen hours by myself? I liked being outside my comfort zone, but this was outside my galaxy.

When I returned from New York City, the first thing I did was add the word "solo" to the picture of the giraffe in the Serengeti on my vision board. I was on a mission.

COVID and fear delayed my plans. Three years later, I touched down in Johannesburg, South Africa. I took a puddle jumper to Hoedspruit and lived amongst the Big Five in Sabi Sand Game Reserve for a week. While I prepared for the trip, people asked who I was going with and were shocked to hear I was going by myself. "Why not," I'd say.

A good friend who I travel with frequently called. "Hey, Betsy, I've been giving it a lot of thought, and I'd like to join you on your trip to South Africa. I've never been, and I think it would be fun."

I was caught off guard by my words taking a spontaneous vacation without informing me.

To break the silence, I muttered, "I'd really prefer to embark on this adventure solo."

My father, a world traveler, was worried about my safety and tried to talk me out of it on numerous occasions. Doubts did creep in from time to time like maybe I would not have an enjoyable time. I'm an introvert and wondered whether I'd feel lonely. I worried if I could stomach the long flight alone, knowing the anxiety I felt flying. Should I bring some sleep aids to assist? No, I concluded. I wanted to feel everything.

During my trip, many asked who I was traveling with. When I said, "Just me," they asked who I was meeting up with. They were surprised when I said no one.

I've traveled extensively in my life, both for pleasure and work, but my trip to South Africa was the highlight of all my travels. Traveling solo created opportunities unavailable when traveling with others. I sat shotgun in the jeep while on safari because I was the only one at the reserve traveling solo. This gave me a front-row view of all the animals and direct access to the guide beside me to answer all my questions. At mealtimes, the staff at the reserve sat at my table. The staff lived in the local villages when not working, and I got

to know them well and what their lives were like at home. I met other guests who welcomed the solo traveler, sharing their games (and delicious stash of chocolate) with me. We exchanged contact information, and I still keep in touch with them today. I felt unprecedented energy and freedom on this trip, and I came back to the States planning my next solo travel. Vacations, like holidays, don't need to be put in a box. They can be whatever, and however we define them.

rescue me

For most of my life, I have shared my home with four-legged furballs. As a child, our family had several dogs, including my favorite, the black Labrador Retriever. Fresh out of graduate school, my former husband and I raised dogs for The Seeing Eye in Morristown, New Jersey. We had our pick of several breeds, and because we were partial to Labrador Retrievers, we picked this breed and raised several labs for the organization over the years. After we divorced and it was time to get a new family dog for my daughters and me, I decided to go the rescue route.

My daughters and I scoured the internet for days, looking for our next Fido. One afternoon, Oliva's mugshot popped up in our search on Petfinder. The ad described Oliva as a black and tan, eight-week-old Labrador mix. Her mug shot showed Oliva's paws reaching toward the camera as if to say, "Take me home."

Oliva was with a rescue organization two hours south of us in Orlando, and when I called to fill out an application for her, I was told she would go to the first qualified applicant. I quickly emailed our application, and the girls and I jumped in the car. We didn't want anyone to get to her before we did.

On our drive down the Florida Turnpike, we discussed names. Over the sounds of cars whizzing by us going 80 mph, the girls shouted out "Lucy," "Bella," and "Zoe." After twenty minutes of calling out names, a black Dodge Dakota truck roared by us and Maria shouted, "What about Dakota?"

"Perfect!" Elena and I exclaimed in unison.

We had our name; now, we just needed our dog.

We met a woman from the rescue at a PetSmart in Orlando at 7 p.m. Oliva was in a large shopping cart with two of her eight siblings. I picked Oliva up, and she was so jumpy I could barely hold her. I set her back in the cart and picked up her sister, who was so tired she struggled to keep her eyes open. I held her to my chest like a newborn and breathed in her new puppy smell. We spent the next hour playing with Oliva and her siblings, trying to decide which one to give a forever home. We picked Oliva's sister due to her peaceful, calm demeanor. She just wanted to be held tight and rest her chin on my shoulder so she could sleep.

Several happy years later, Dakota reigns as queen in our home. I find her burrowing to be her most endearing trait, as I've never had a dog that did this. If there is a pillow or cushion anywhere, she'll find it, tuck her head under it, and go to sleep. Fluffy blankets are even better because she can maneuver her body under them, hiding from the world.

Curious about her background, I submitted Dakota's DNA to an online laboratory to determine her genetic makeup. By now, she had grown tall into a 40-pound greyhound-like frame. Her calm demeanor had persisted, and her favorite activity was sleeping. Given that she and her siblings had been left in a cardboard box along Interstate 10, we knew little about her family history, only the information on the Petfinder ad that had said she was a Labrador mix. Several weeks later, I tore open the envelope holding Dakota's DNA results:

- Dachshund
- English Springer Spaniel
- Poodle
- Chow Chow
- Irish Setter
- Papillon
- Airedale Terrier

I read the list again. Had I missed it? I turned the paper over. Where was Labrador? The beloved breed I grew up with, the breed known to be great with children, the breed I had raised for The Seeing Eye. What did I know about Dachshunds, the breed that reportedly made up 36 percent of Dakota's genetic makeup? I knew nothing except the breed has short legs, the opposite of Dakota's. I googled Dachshund for more information and found out Dakota's beloved burrowing, her love of barking, and her long back were very Dachshund-like. The more I read about the breed, the more I saw the similarities. I was shocked but also relieved. Had I known her genetic makeup beforehand, it is very likely I would not have made the two-hour drive to meet Dakota. I would have dismissed the Dachshund box as one in which

I knew little about nor had much interest in. Years later, she has become one of the sweetest dogs I've ever known.

I called the rescue to let them know of the DNA results in the event they wanted to share it with Dakota's siblings' owners. I told the rescue organization how surprised I was that no Labrador showed up in the profile. The woman on the phone said she was not surprised at all.

"Really? Why?" I asked.

"Because we can't tell what breed a dog is just by looking at them. Even a veterinarian can't tell you for sure without a test."

"That makes sense, I guess. So, how do you decide what breed to put down in your rescue ads?"

"Look, honey. Our goal here is to find these dogs a home. We put down the breed we think will attract the most people."

Never had I been so grateful for a rescue organization's strategic manipulation of boxes. I had Dakota as a result.

sprechen sie deutsch?

My friend Laura's father left her and her mother when she was a toddler. He was German, and Laura's mom was Chinese. As a child longing for her absent father, she adored her German heritage, bonding with the country's rich culture, food, and language. Anything German would remind her of her father and the bond they shared, including the German eagle coat of arms that adorned her hallway wall.

Two years ago, Laura's daughter gave her a DNA test from 23andMe for Christmas. For months, Laura looked at the DNA kit sitting idly on her distressed oak dresser. She had heard stories of her father's wild womanizing ways and feared the unknown. After much encouragement, Laura spit a half teaspoon of saliva into the test tube kit and mailed it off.

Six weeks later, a 23andMe envelope arrived in Laura's mailbox. She waited until her kids were available to open it,

and over a Zoom call, she opened the envelope and read the results to them.

"I'm half Chinese," Laura said.

"Mom, that we know," her eldest said. Laura's children were close to Laura's sister and mom, and their Chinese heritage was special to them.

"Okay, it says I'm also one-sixth Irish, one-sixth English, and one-sixth Scottish." She stared at the results. "Wait, where... where is my German?" she mumbled.

"Mom, read further; I'm sure it's there," said her youngest. Laura reread the results. German was not listed.

Laura called me in tears a few hours later. For fifty-eight years, she had checked the German box. To find out there wasn't an ounce of German in her was a huge and unexpected loss for her. She was more upset over this than finding out she was one of twenty children her father had sired. A part of her identity had been stolen. The fact it was never hers didn't matter.

parentheses

I was visiting my sister at her family's home in Charlotte, North Carolina, a few years ago. From the bedroom I slept in, in the dark silence before dawn, I heard the thump of the newspaper as it landed in my sister's driveway. I looked forward to reading a national business newspaper when I visited my sister as I had long ago dropped my subscriptions to daily newspapers.

On this particular Saturday, I was reading the paper in a gently worn red armchair nestled by the wood-burning fire crackling in the fireplace beside me, which kept the room toasty warm on that cool December morning. I picked up the business section and read an article about a company's founder and the enriching culture she was creating. I read another article about a new technology that would revolutionize the healthcare industry. Thirty minutes later, I had read the entire business section and moved on to world news.

A few minutes later, I felt unsettled. Something I had read nagged at me, but I could not figure out what. I picked up the business section and reread the last few articles. That's when I saw it, like a train headed straight toward me. Every article highlighted people in prominent positions in their businesses. In each story, after the author first introduced the protagonist, if it was a woman, her age was inserted in parentheses behind her name: Mary Smith (47) Every time a man was introduced in an article, his age was not mentioned.

I went through the entire section, checking every article. Each followed this pattern. How could this be? Why was knowing a woman's age relevant to the story, and if it was, why weren't men's ages also published? Wasn't their age ever relevant? Also, since different authors had written these articles, why did each follow this format of introduction for women-featured businesses? Was this a standard dictated by the paper? And furthermore, where did these people's ages come from? I've been interviewed for many newspaper and magazine articles and never have I once been asked my age. It's more likely the authors (or editor) researched the women's ages and added them to the article unbeknownst to the women featured.

I felt my blood vessels constrict as they often do when I'm cold, my body in survival mode, minimizing heat loss to preserve my core. By then, I was a voracious consumer of business newspapers and magazines. I'd never seen this practice before. I fired up my laptop and shot off a letter to the editor of this national newspaper explaining what I had uncovered. A month later, I received a personal email reply from the paper's editor. He had reviewed the section in question and saw I was correct in my observation. He assured me he was looking into why this had occurred and thanked me for bringing it to his attention.

We live in a society where age, in general, is not valued unless we are young. In other cultures, age may be revered, but in ours, it is not, especially for women. Women in the media often talk about hitting their forties only to find offers for work evaporate. Plastic surgery may buy women another ten years if they are lucky. One of the reasons I went into real estate was because I saw successful female Realtors in their eighties still happily thriving in their business. I knew I wouldn't age out in the industry if I chose to continue working. I hadn't seen that in the pharmaceutical industry I previously worked in. Gray hair on men is said to be sophisticated. Sadly, I've overheard many middle-aged gray-haired women being talked about, behind their backs, even by other women: "Why'd she let herself go?"

While I'm not a subscriber of the aforementioned newspaper, I check periodically to see how its articles reference women. As of 2024, I see no evidence that this practice exists today.

Amending harmful boxes often involves more than writing a letter; we must be willing to call out people, organizations, and systems that use boxes destructively if we want to see change. In my twenties, I would not have recognized the age box women are put in, as my currency was at its peak. In my fifties, I have the experience to recognize the box and the courage to call it out.

museums

My father is a consultant for pharmaceutical companies when he's not working at the hospital or running clinical trials. He often travels around the globe to speak at conferences. Growing up, my mom would stay at home, and my dad would take me or one of my sisters as his plus one on his trips. As a result, my sisters and I each have a roster of countries and memories we have collected with my father. In addition, in our summers while growing up, we often went to Europe for my father's meetings and stayed to travel as a family.

Being a scholarly family, we always checked out books from the library on the countries on our itinerary, learned about their history, and spent hours in famous cathedrals, estates, and even pyramids. While I loved seeing other cultures, what I dreaded most were museum days. We'd wake up early to be the first ones in line. Once in, I'd feign interest in

the sculptures and the small font storyboards outlining the history of the country's political parties and would play mind games to pass the time. Count from one to one hundred by threes and back again. Recite the alphabet backward. Square every number from one to fifty. I spent so much time in the museums' bathrooms, gift shops, and cafés, I had more frequent flier miles with them than I did on Delta.

My lack of interest in history was apparent in middle and high school. Trivial Pursuit was a popular game in the 1980s, and I bombed the simplest history questions when I played with my friends. I excelled in math and science yet could barely stay awake in history. Fortunately, I mastered the art of memorizing and made it through, forgetting all that I had crammed into my head the day after every test.

About ten years ago, my parents, sister, and I planned a trip to Italy, where my father still has distant relatives. My sister was planning an extensive itinerary filled with historic buildings to tour and museums for all of us to see. When she emailed me a barrage of links to what she was booking for us, I felt a knot getting comfortable in the bed of my stomach.

I knew I could not do our standard litany of museums again. But I had to break it to my family, who valued education and knowledge more than anything else, that my idea of a vacation was not visiting museums, getting a repeat of the history lessons I so despised in school. I was restless about having this conversation, convinced I needed to bow out of going on the trip altogether.

I was already the black sheep for not going to medical school. Now, I had to tell them I didn't share that highly valued currency, edging myself out of the Pepine family box even more. I wasn't sure I could handle the emotional toll this would take on me.

One morning, I woke up with newfound courage and picked up the phone.

"Mom and Dad," I said, "I'd like to go on this vacation with you, but I need to do it differently this time."

"What do you mean?" my mom asked.

"I can join you every other day in your activities but I need to do some things on my own that I enjoy. You guys like museums and buildings and estates and history. I don't care for these things. I prefer more active excursions—cooking classes, wine tours, biking, hiking, and eating at fabulous restaurants. And immersive travel where we meet locals and see the city through their eyes."

"That is different from what we are used to, but it's fine with me. That actually sounds like fun. We may even like to join you for some of those activities if you wouldn't mind."

Where were the walls I had imagined? The resistance I had braced myself for? I felt acceptance, not shame. I unclenched my jaw and, like the Grinch, I felt my heart grow three sizes that day.

A few months later, we took that trip. I went off on my own like I said I would. Every other day, I experienced the cities in a way that resonated with me and joined the rest of my family on the other days doing the things we had done on trips past.

I came back feeling like a weight had been lifted. I had felt confined vacationing with my family in the past, having to follow other people's agendas and endure their idea of fun. I feared that by speaking my truth, I'd disappoint them, not living up to the ideal they had in their mind of me. Instead, they were receptive to my plans and even participated in some of my activities.

Like the adult elephant who believes he can't move because he's shackled to the same small stake that he was when he was little, maybe some boxes we are in are more imagined than real.

panels

ast year, I attended a well-known annual real estate conference, the first one held in person since COVID. After two days of great talks and panel discussions with top producers, team leaders, and industry vendors, the organizers asked for feedback at the conclusion of the program. I approached the president of the company that hosted the conference and told him that while the conference overall was well-received, it was hard to relate to his panel of all-white, middle-aged men. He looked dumbfounded. I was dumbfounded in return. How do you not notice your panel members all look as if they were cut from the same bolt of fabric? Perhaps because the panel was chosen by men who looked like the panelists.

Later, I was at another conference attended by some of the most successful entrepreneurs in North America. At lunch one day, I sat next to a prominent commercial real

estate broker from New York City. Having just plated our lunches from the buffet line, he delved into his Caesar salad and asked what my hot projects were for the year.

"I'm working on a book," I said.

"That's great. Can I ask what it's about?"

"Boxes," I said, as my mouth watered over the basket of hot yeast rolls the waiter had just set on our table.

"Boxes? What do you mean by boxes?"

"It's about the boxes I have found myself in throughout my life, why I'm in them, and how I get out of them if they aren't serving me."

"You mean to tell me you feel you've been put into a box?"

I buttered a bite of roll. "Yes, since the time I was a little girl, I've found myself in boxes."

"I'm really surprised to hear that. I have two daughters. They are ten and twelve. I don't look at them any differently than if I had sons."

"Do you have sons?"

"No, but I would look at them the same way as I do my girls if I did. And I see you sitting here beside me, and I see a successful businessperson. I don't look at you and see anything but an entrepreneur. I don't see male or female. I just see you."

"That's great. I'm really relieved to hear that," I said.

I went to the dessert table and returned with two mini pecan tarts.

"But do you know what really makes me mad, Betsy?" my table mate asked. His face was now the color of the red Gala apple on my plate, and his voice rose in anger. "Do you know who's in the least protected class in America today?"

"No, who?" I took a bite of my tart.

"Me. The white, middle-aged man. Nowadays, everyone has their own group to help them fight for their rights.

You've got your women's groups, the gays have LGBTQ groups, Black people have minority groups. You know what I want to know? I want to know where my group is."

I paused, brushing crumbs of the pecan tart off my face. "Do you really need a group if you are sitting on the top of the totem pole?" I stood up as his dinner roll took up residence in the middle of his throat.

hail mary

I was fifty-three years new and looking for a church home in Florida. I was raised Catholic by parents who were also raised Catholic and taught by Catholic nuns. I missed exactly one Sunday Mass in my first eighteen years of life, and that's because I was born on a Sunday.

In 2022, with both my daughters off at college, I started church shopping, looking for a new spiritual home. Although my daughters and I had at one time been very involved in a Methodist church when they were growing up, I had not been active in a church for a while and felt something missing in my life. I took a class at one church and went to a service at another. I looked at websites, listened to sermons online, and asked friends for recommendations. I sat in services that felt like rock concerts, in dimly lit sanctuaries where people hung in the back by the coffee bar, and in churches where the pastor was streamed in on a jumbotron because he lived in

another state. Despite these varied experiences, nothing felt quite like home for me.

After much deliberation, I decided to return to the Catholic Church, where I was raised and married. I experienced a level of comfort there because I'd spent so much time there in my youth. However, I felt a bit inauthentic knowing I did not believe in some of the religion's teachings, nor did I practice some of their rules. I decided to start off this new chapter authentically and scheduled myself for confession, something I hadn't done in over thirty years.

As my scheduled confessional time approached, I began to ruminate. What should I say? Would I remember to kneel? I recalled the opening lines starting with, "Bless me, Father, for I have sinned." After that, I was not sure what to say. I figured I'd just wing it.

When I got to the church at 5 p.m., I saw a line of people trailing down the far-right side of the sanctuary. I waited patiently for my turn, literally praying my confession would go okay. When it was my turn, I walked slowly to the door, turned the handle, and walked into the small, dark room to take it all in. I immediately recognized the smell of smoky incense. Noses never forget a place, and I started to relax. I looked ahead and saw where I could enter the dark wood confessional box. Memories of it housing a small prayer bench and red kneeler that I used as a child flooded my mind. I entered the confessional box quietly and sat down. To my left was the deep purple velvet curtain, behind which sat the priest I could hear breathing heavily. In a split second, I yanked the curtain back. I wanted to be face-to-face; I was all in.

Father John jerked his head up, surprised by my presence. I don't think he was used to someone wanting to do

a face-to-face confession. At fifty-three, I was done hiding and sat down.

I took a deep breath and made the sign of the cross. "Bless me, Father, for I have sinned. My last confession was over three decades ago."

There was a pause. I was not sure what I was supposed to say next.

"Go on," Father John said.

"Um. I'd like to... I would like to come back to this church, but only if you know my beliefs and are okay with them."

"Please continue."

"Father, I've been married. I slept with my former husband before we were married. I've been divorced. My marriage was not annulled, and I have no plans on getting it annulled. Oh, and I use birth control and will continue to do so."

Father John looked at me blankly. He'd clearly done this before, but I wasn't sure how to read him.

I continued. "Years after my divorce, I lived with a man in sin. I have two daughters. They are both lesbian."

Still no expression from Father John.

"Most importantly, Father, you have to know that I'm okay with all of this."

He looked at me and said, "Is that all?"

"There is one more thing. I think we should let women be ordained as priests in the Catholic Church."

"Now, are you finished?" Father John asked.

"Yes, that is all."

"I absolve you from your sins, in the name of the Father and of the Son and of the Holy Spirit. Say three Hail Marys and two Our Fathers."

I waited, thinking he was going to say more.

Then I heard the sound of a clicker go off in his hand. I looked down and saw he was holding a gold-toned tally counter in his left hand, counting the number of people who came through confession, signaling my time was over and that I was just another statistic in the congregation.

I walked out to the sanctuary into a pious pew, whereupon I set the kneeler down to do my penance, feeling free from the bondage the Catholic box had had over me. I would no longer feel like a hypocrite when I stepped into church.

status

I married when I was twenty-four and divorced when I was thirty-three. Though I've dated and been in other long-term relationships since, I have never remarried. Not a week goes by without someone asking whether I'm seeing anyone. I'm not sure why my dating status is so important, and often wonder if single men are asked this as frequently as I and my other single women friends are.

What I find interesting is when people ask, as hard as they try, judgment creeps onto their faces when I answer their question. When I say I am dating someone, they smile, giddy almost. Hands clap, or I hear an animated "Oh, how exciting! That's great. Tell me all about him." If I share that I'm not dating anyone, silence follows, and I either get an exaggerated sympathetic look followed by a version of "Aw, I know how hard the dating pool is for people our age," or the person appears to be searching in their minds for someone

with whom they think I might be compatible. Regardless, they presume my single status is a problem that needs fixing.

In a patriarchal society, it is taboo for a female past her twenties to admit she's happily single. I love my single life more than I ever did when I was married. I find when I'm unattached, I'm more social and my life is fuller than when I was married or when I'm in a relationship. I see more, do more, travel more, and experience more when I'm flying solo than when I'm partnered. I've founded five companies. I've created a non-profit. I have more friends than I've ever had. I've traveled the world. All while being single. I'm not a spinster. I am not anti-romantic. I'm not so focused on my career that I won't make time for a relationship. I'm not trying to convince everyone else they should be single. I'm not opposed to marriage, but I find as I get older, the appeal of being in the marriage box has waned. When people ask me if I'm single, I now say: "Yes, consciously so."

insurance

A large white marquee sign outside the local florist shop promotes its weekly specials. I drove by it yesterday and a new slogan had been put up. "Stop in. We sell wife insurance," it said.

While I appreciate the business owner's play on words, I find such statements demeaning as they suggest women can be bought. The media reinforces this message with headlines like "Kobe gives wife ring shortly after admitting adultery"[7] reported by ESPN in 2003. Having been deceived by an adulterous husband, I can attest no ring would have ensured that I look past a serious breach of trust. The idea of thinking that my trust can be bought with a ring or flowers is beyond belittling.

For two years during college, I worked at a local florist off East Campus during peak "flower" holidays. I loved working amidst the deliciously scented peonies and the flamboyant

white- and pink-petaled lilies. As far as holidays go, the granddaddy of them all for florists is Valentine's Day, and each year, I took phone orders nonstop the week leading up to February 14. I remember one exchange with an eager male caller.

"I'd like to order a dozen red roses to be delivered on Valentine's Day."

"Sure thing. How sweet. To whom is this going?"

"I'd like it sent to my wife. Her name is Nancy."

"And what message would you like on the card?"

"Let's go with, 'I love you. Bill.'"

"Great. Is that all, Bill?" I said.

He cleared his throat. "I need one more thing."

"Sure, what's that?" I flipped to a new order form.

"I need another dozen roses. And I need those sent to Mary."

"Aw, how nice. Is Mary your mother?"

"No. No. Mary is, um… Mary is my girlfriend."

"Oh… okay," I said, nervously wrapping the phone cord around my finger.

"Umm… So, you want us to send a dozen red roses to your wife and send another dozen to your girlfriend?" I repeated, hoping I misunderstood.

"Yes, perfect. You got it. Thanks so much."

"And, what then would you like me to write on Mary's card?"

"Let's keep it simple. The same thing, 'I love you. Bill.'"

Flabbergasted, I walked the order over to the shop owner. She laughed and said this happened all the time. My eyes opened so wide I feared my eyeballs would eject from their sockets while my mouth dropped open to form a long oval. "So, we are going to deliver flowers to both these women on Valentine's Day?"

"Yes, it's business, Betsy. Just make sure you don't mix up their names."

Since then, I've come across numerous flower shop owners who concur this is not an anomaly. Not only does my local flower shop's marquee promoting it sells wife insurance demean women by suggesting something as simple as flowers erases an indiscretion and placates a wife, but many florists are also fine being an accomplice to such indiscretions.

These florists don't sell wife insurance; they exploit it. By doing so, they reinforce the subordinate box women are put into: a box that apparently can be bought.

april

During my junior summer in college, I worked for McNeil Pharmaceuticals, a division of Johnson and Johnson, in Fort Washington, Pennsylvania. Needing a room for the summer, I responded to a newspaper ad from a sweet widow named May, who lived in a quaint community in Ambler, a few miles from where I'd be working. When I signed the room rental agreement, May told me her current renter would be overlapping me by a week, so I'd have a roommate for the first few days.

I moved into May's house a couple of weeks later. On the first night after dinner, a woman a few years older than me came into the house. May introduced me to April, my roomie for the next several days. They laughed when I joked that I should have been named June to complete the trio.

April and I stayed up talking late into the night that first night. She had graduated from college a few years before and

had been working nearby for a management consulting firm for the last two years. She was leaving to travel for the summer before starting business school at Harvard in the fall.

"I've never met anyone who's gotten into Harvard before. That is so cool," I said.

"I applied to several schools, but Harvard was my first choice. I can't wait to start."

I knew that business school was in my future but I never dreamed of going to a place as prestigious as Harvard.

"My plan is to go to business school, but I'd never get into a school like Harvard."

"Why not?" April asked.

While I had always excelled in school, the truth was I never felt very smart. My father had a photographic memory and was accomplished, known around the world for his academic research in medicine. My sisters were also incredibly bright, and in school, I often scored a point or two below my twin sister. She graduated first in our high school and I had graduated with a B+ in a class, making my class rank just below hers. Because of this, I'd always felt I wasn't very bright. Hence, when I was thinking of business schools, I assumed I'd go to a school-based more on location than reputation.

April and I went on to discuss the jobs I had held and the things I had accomplished in college.

"Betsy, it sounds like you'd be a great candidate for a top business school. You are no different from me. And you'll never know unless you try."

April left a few days later, but her advice has stayed with me to this day. I had never put myself in the "Harvard-material" box, but my brief encounter with April changed the way I viewed myself and the opportunities in front of me. I ended up going to The Wharton School of Business at the University of Pennsylvania because my future husband

was stationed in Philadelphia at the time, but would never
have had the courage to apply to such a program had I not
crossed paths with April. Those few days April and I spent
together changed my life. I now see the immense value in
seeking role models who have broken into boxes I want to
enter. And whenever I doubt I will fit into a particular box, I
think, "Why not me?"

chalkboard

I enrolled my older daughter, Maria, in preschool when she was four. I signed her up for two days a week, but after a few weeks, she was begging to attend more often. Soon, she was going five days a week. Maria loved everything about school—the teachers, her friends, and especially the things she was learning. Toward the end of the school year, I learned the preschool staff held a graduation for the five-year-olds going off to kindergarten in the fall. The ceremony would be followed by a dance.

The whole idea of a preschool graduation seemed odd to me. Maria had only been there six months. When I grew up, high school was the one graduation ceremony you were guaranteed. Many kids went to college and got another one, but preschool?

Fliers were sent home in preparation for the big day. Teachers would wear formal attire, girls were expected

to wear fancy dresses, and boys suits for their big day. In addition, the teachers would pair every boy with a girl to accompany them into and out of the ceremony and then to the dance outside.

I was astounded when I read this information. At the time, Maria loved wearing dresses, but what if she didn't? I sure as heck wasn't going to make my child wear a dress if she didn't want to. And why was the school pushing boy-girl match-ups, or any match-ups for that matter, at the age of five?

I went into the preschool the next day and told the administrator that while I wanted Maria to participate in graduation, I refused to let her be matched with a boy to escort her into the ceremony and subsequent dance. Maria was fearless and confident; she didn't need anyone by her side. She would walk in by herself just as she had every other day of school that year. The administrator was surprised, explaining to me that no parent had ever voiced a complaint about their graduation protocol, but I had the right to decide what was best for my child.

Maria graduated unaccompanied and unscathed a few weeks later and enjoyed the ceremony and dance as much as the other kids. Her confidence grew three sizes that day.

That fall, Maria found out she was in Mrs. Johnson's kindergarten class at Wiles Elementary. Maria loved school and couldn't wait to start the year. I walked her into Mrs. Johnson's classroom the first week to make sure she was okay. Boy, was she okay. Mrs. Johnson is one of the most creative people I have ever met. When I walked into her classroom, I thought I had walked into a huge aquarium. Lifelike fish and sea creatures hung from the ceiling. Seagrass was growing

out of the walls. Underwater, bubbly sounds filled the room. It was so immersive that the fire marshal shut Mrs. Johnson's classroom down midway through the year for fear her decor would start a fire.

On that first Friday of the school year, I stayed a few minutes to chat with Mrs. Johnson. When I turned to leave, I saw a large whiteboard spanning the entire front wall of the classroom that I hadn't noticed before. On the top left corner of the whiteboard, I saw a box outlined in red marker with a list of six or seven students' names. I quickly scanned the list, looking for Maria, relieved when her name was not there. Seeing the list, I felt a bit deflated. I remembered my own grade school classrooms and the fear I felt should my name appear on the chalkboard and how disappointed my mom would be when word got back to her that I was on the naughty list. Curious, I asked Mrs. Johnson, "What did these kids do to get their names on the whiteboard in just their first week of class?"

"Oh, that. That's my 'Catch You Doing Something Right' list. When I catch a child doing something right, I write their name on the board for everyone to see. On Friday afternoon, today in fact, all the kids whose names are on the board will get a special treat."

Oh, how I loved hearing this. Mrs. Johnson knew how to turn a box on its head, and I knew that Mrs. Johnson and I were going to get along just fine that year.

more boxes

I sell houses for a living. Every day, I watch people box up their entire lives and move across the country or across town for the chance at a better life. The death or birth of a person, relationship, or job results in many moves. Others move because they want to get away from something—their neighbors, family, the rules of their homeowners' association, taxes, and so on.

Regardless of the motive, it's fascinating to watch as we pack our complicated lives into simple brown boxes. The last time we moved, I did most of the packing. I dumped the contents of the utensil drawer from the kitchen into one box yet carefully wrapped dishes in another. Clothes were neatly folded and put into several boxes; the nicer ones hung in a standing wardrobe box. When a box was full, I sealed it with clear industrial moving tape. Then came my favorite part. The black Sharpie made its debut to assist in the

move. I would think for a moment and then bend down and write, "Kitchen" or "Bedroom" or the dreaded "Attic" on the box, the box that gets stored in the attic upon every move, never again to be opened. Then I'd walk the box out of the house and place it in a larger box—the large moving portable on-demand (POD) storage box that sat in our driveway.

Later, when the POD was being unloaded, my younger daughter Elena asked a mover, "What's in the box?" The mover shrugged his shoulders as if to say, "How the hell do I know?" Elena looked down at the box and saw the label written in black Sharpie ink. "Oh, it's just kitchen stuff." With the easy-to-read label, there was no longer a need to know the box's contents—the label said it all. Everything in the box was now collectively deemed "kitchen stuff."

This reminds me of walks I took with my daughters when they were toddlers, happily showing them the world. Every day, on our walk in the woods behind our neighborhood community pool, I'd hold their hands, stop, and show them the different types of trees we were walking by, patiently describing each one. I had them hold the leaves from the different trees—some as small as a pebble and others the size of their heads. I'd have them touch the bark—one tree's bark was smooth, the other rough. One tree had no bark, and Maria and Elena loved running their fingers down this tree's naked trunk. Some trees bore beautifully scented flowers, others were flowerless. Over our daily walks, we compared the various shades of green and brown on the trees and the golden and red leaves as the summer turned to fall. I taught Maria and Elena the word "tree" as we did our daily discovery. They pointed to a tree and repeated after me, "tree."

Every day for the next week, Maria and Elena, on their walk, ran up to each tree they saw and said "tree" and gave it a hug.

One day, I stopped at the first tree in our path to talk about it and Maria tugged at my hand. "Mommy," she said, "I know, Mom. It's just a tree," and pulled me along to keep moving. I stopped at the second tree on our path. This time, Elena said, "Mom, let's go. We know it's a tree."

The moment we learn the word for something, we stop seeing it. We assume we know its essence just by knowing its name. Hence, it's just a tree if all trees are the same. The same holds true with boxes. Once we label a box, we can stop seeing the nuances of what's inside. It's just the kitchen box or the basement box. The same applies to people once we put them in boxes. We can stop seeing the people and see only the box and assume everyone in the box is the same. He's a priest; I know what priests are. She's a physician, a Jewish person, a single mom, a female, an older person, a gay person. I know then what they are. No need to explore further, become acquainted, cast judgment and expectations aside, and really understand their essence. While categorization is essential to be able to assimilate everything our minds process, boxes can be an obstructive shortcut to discerning who someone is.

simple things

While writing this book, I joined a local authors group to get feedback on my work. For our meetings, participants submit their writing a few days early, and the others comment on the work in a shared Google document. Then, during a Zoom meeting, each document is brought up, and the commenters provide further explanations for their comments.

For my first session, I submitted my table of contents and a few stories. Anxious for feedback, I joined the Zoom call at the appointed hour, where several other more experienced writers were already present. When my turn was called, I opened the document with my chapters and saw the first comment beside my table of contents: "Why haven't you capitalized the chapter titles here?"

Great question. "Before I answer, I'd love to understand the reasoning behind you asking it," I said to the commenter.

"Well, it's just that I've never seen chapter titles like this. They're always capitalized," she said.

"Thank you. That is exactly why they are not capitalized."

"I don't understand. What do you mean?"

"I'm writing a book about breaking out of boxes—breaking out of the expectations others place on us, often for no reason other than 'that's how we've always done it, that's what I know, that's what makes me feel most comfortable.' I don't want my chapter titles capitalized. I like the way they look uncapitalized. They seem less formal and more casual, like me. And I love that it's the first thing you see in the book."

"Wow, I love that! It was a bit unexpected and made me ponder why you made that choice," another woman writer chimed in.

This is exactly what I wanted my book to do. At my first brainstorming session, my editor asked what my goal was in writing a book. I told her it was very simple. If I could have just one reader who, upon finishing the book, thought about something differently, questioned their assumptions, and examined why they do what they do, the book would be a success.

Thank you, writing pod reader, for the validation.

costumes

While some boxes are invisible and hard to detect until we've been in them for some time, other boxes are so transparent they come with their own props, titles, and expectations. Hitler, referred to as der Führer, required Jewish people to wear a yellow Star of David patch to visibly show the world the box in which he placed them. In literature, Hester Prynne was shamed into wearing a scarlet letter A to show the world she was in the adulterer box. Inmates wear orange jumpsuits, making it difficult to escape the prison box without being recognized. The long white robe a priest wears is a dead giveaway for the box a spiritual leader lives in. When someone told me about a friend of theirs who loved fine wines and attended cooking classes around the world, I was surprised to learn she was referring to her priest. That seemed inconsistent with what I expected to find in the priest box. Likewise, we are shocked when we

read that a deacon has molested children. It seems so contrary to the expectations we have of those in the box wearing the costume and holding the title. Such boxes can be dangerous because there is an inherent hierarchy to them. With hierarchy comes power, and with power can come abuse.

The military requires uniforms not just to protect skin but to denote rank and status at a quick glance. We salute and address members by their title of colonel, captain, or lieutenant. Law enforcement is similarly boxed, and there was a time we were shocked to see police officers' brutality, as it's contrary to what we expect from those committed to protecting the public. Boxes with costumes and rank even show up in the kitchens of the finest restaurants. Chefs wear double-breasted jackets and tall white toques on their heads. Seeing them wear monogrammed jackets with their title, everyone in the kitchen knows who occupies the executive chef's box.

These boxes remind me of a story my twin sister Anne shared with me. Anne was a stay-at-home mom with three young children. Several years ago, she was due for her annual eye exam, and she had recently switched optometrists. At her first visit with the new practitioner, she was asked basic information (name, date of birth, etc.) on the patient intake form. Upon completing the form, a technician took Anne back to an examination room, where she was told the optometrist would be in shortly. After twenty minutes of waiting on a cold examination chair, Anne was about to leave when a pompous, too-cocky-for-his-age twenty-something-year-old man fresh out of optometry school swept into the room in his white coat with his name monogrammed in blue. With a bit

of a smirk suggesting irritation, he said confidently, "Hello, Anne, I'm Dr. Richards. Don't you worry, I'll be examining you today." His proud plume of feathers expanded.

My sister paused and took a breath. She looked up at him and said with a smile, "I'm sorry. I don't believe we've met. I'm Dr. Monroe."

Dr. Richards' face paled, clearly embarrassed. He assumed my stay-at-home sister with three kids was not a physician. My sister, an MD twenty-five years his senior, trumped him in his own box.

roles

After my divorce, I dated a guy for a few years who had three daughters born in the late 1980s. When we first met, he told me their names. I noticed immediately they were all androgynous and asked him why. He said he chose those names so his daughters would not be discriminated against when a recruiter was reviewing resumes. As the head of the department of a large medical system, he interviewed a lot of people for his employer and found it hard not to discriminate when reviewing resumes by assuming someone's gender based on their name. He wanted to give his daughters every advantage in the workplace.

When we watched TV, this man would comment on commercials he felt were sexist. He despised ads depicting a mom in the kitchen preparing food, mopping the floor, or helping the children with their homework. I assumed this was because he felt the ads were depicting women in

traditional roles not particularly esteemed by the society in which we live, and hence, portraying them in a negative light. I was wrong. He was upset because, as a single dad, he did all those things and was frustrated he never saw someone like himself in these ads. Why did women get all the credit for raising children, cooking, and cleaning?

I have never been fond of such commercials, but for very different reasons. I had never considered his view before, a male upset for being excluded in roles traditionally depicted as female. He felt similarly when teachers asked him if their daughters' mom had seen the field trip note or signed the report cards, as though the mother had complete reign over all issues regarding her children's schooling.

While most roles deemed feminine in our society are devalued, this man wanted to be recognized for such roles. It's a view not often heard but one that needs recognition. Boxes affect everyone in the ecosystem and only through awareness can we become better at recognizing them and limiting their harmful influence.

assessments

I n corporate America, personality assessments are a popular part of the hiring process. Employers want to make sure a candidate has the necessary skills and personality traits to do a job effectively. The more insight they have on a candidate, the better they can match a person to the job. I was first introduced to the Myers-Briggs Type Indicator personality test in business school. When taking a management class, my professor administered this assessment one afternoon. After analyzing my ninety-plus answers, he told me I was among the 12 percent of the population who is an ISTJ. This means I'm an introvert who is sensing, thinking, and judging.

In my brokerage, we often use the DISC Assessment profile in hiring. I'm a DC, also known as a Challenger, meaning I'm direct, straightforward, high-energy, analytical, and results-oriented. In my entrepreneurial mastermind groups, we use the Kolbe A™ Index, where I'm 7463. This

means I like to use facts to make decisions and am a quick start. CliftonStrengths, an assessment my church uses to help triage members' natural talents, determined my strengths are intellection, input, and learner. Also, at church, I took a relationships class taught by expert Mark Gungor. He uses a Flag Page test to assess temperament and puts people in one of four countries—the Peace, Fun, Control, or Perfect Country (I live in the country of Control). In the PRINT Survey, I'm a 1:5, which means I like things to be perfect, and I value being knowledgeable and smart. I'm an 8, the Challenger, in the Enneagram. In fashion, I'm a Bright Winter, so I look best in cool, highly saturated jewel-toned colors. I'm a Type 4 in Carol Tuttle's Dressing Your Truth energy typing system, which is characterized as a bold, striking woman.

I love assessment tests because they help me understand aspects of myself not in my consciousness. They've shed light on the traits I have, who I am, and how I naturally operate.

I first learned I was an introvert when I took the Myers-Briggs assessment at Wharton. I took the test a second time because I felt being an introvert was a bad thing and the test result must have been a mistake. The second time, twenty minutes later, the test still deemed I was an introvert.

Although I was disappointed in the result, the assessment piqued my interest and I started researching more about introverts. I began to understand aspects of my personality better. Most importantly, I learned I was not alone. There were other people in the introvert box. Inspiring people, motivating people—people changing the world. The theory of relativity, the Montgomery bus boycott, *E. T.*, the Emancipation Proclamation, and *Breakfast at Tiffany's* were created by or featured introverts like Albert Einstein, Rosa Parks, Steven Spielberg, Abraham Lincoln, and Audrey Hepburn. According to Einstein: "The monotony and

solitude of a quiet life stimulates the creative mind."[8] I've since come to love living in the introvert box and embrace the need for alone time to perform optimally.

shy

The United States is designed for extroverts. Up to two-thirds of Americans are extroverts, and Western society is geared toward and rewards extroversion. Being high-energy, outspoken, and socially driven is highly valued. Power is often bestowed on extroversion because, as a group, extroverts are more vocal, are seen as more popular, have a greater number of social connections and influence, and are more likely motivated by external rewards.

Being in the introvert box is difficult in a world full of and designed for extroverts. I have never been confused with being the life of a party, monopolizing the conversation, or needing all eyes on me. In this box, introverts are often misunderstood. We are often described as shy and poor at communicating. I am quiet and contemplative. But I am not shy, and I have no trouble speaking my mind. I am direct and forthright when I do choose to speak. But I prefer to listen

more than talk. I value learning and find I learn much more when I'm quiet.

Introverts are often told we can't be successful in an extroverted world. I'm a part of an elite group of entrepreneurs, some of the most successful people in business. Two-thirds of the group are introverts. Being successful as a leader or in sales means we solve other people's problems. To solve other people's problems, we must know what their problems are. To determine that, we must be active listeners. Introverts generally excel at listening.

Introverts are sometimes described as boring, having nothing to say, and lacking creativity. I think of it differently. We value silence. We don't have a need to fill every second with conversation. We like to think through things before we speak. We are conscious of our thoughts, feelings, and tone and want to be sure what comes out is in the way we intended. Also, many introverts are avid readers and lifelong learners. We have so many ideas popping into our heads that we need time to triage them before we are ready to talk about them. I keep a pad of paper and pen with me at all times because the ideas come in so fast; I want to capture them all. The alone time I crave helps me process them and have creative breakthroughs.

Living as an introvert for over fifty years, I see how our culture encourages us overtly or subtly to vacate our introvert box. Like the singles box, many extroverts view introversion as a condition needing to be fixed.

The forced distance COVID imposed was an introvert's best friend. Can't meet in person? No problem. Annual conferences on Zoom? Fantastic. I'm a member of numerous professional organizations, many of which meet annually in large cities like Las Vegas, Chicago, or Los Angeles. Annual conferences usually last two to three days and run from 9 a.m. to 5 p.m., followed by a reception, dinner, and an evening

outing or entertainment. I used to force myself to attend all the events on the conference agenda. My colleagues seemed genuinely excited about going to a Cubs baseball game or meeting Celine Dion before her show after a daylong meeting, and I'd wonder what was wrong with me. All I wanted to do was go back to my room and decompress. Fearing I was missing out, I would attend these events, knowing how taxing it would be for me to be around people all day and then at night with no downtime.

After years of doing conferences like this, I read the book *Quiet* by Susan Cain and other articles on introversion. This newfound information freed me from the burden I thought introversion was. I learned of the many misconceptions of our personality type and a theory that introverts are innately more attuned to their surroundings. They absorb more of their environment than extroverts, and because of this, they feel drained more quickly than extroverts. Needing to recharge, they are most effective recharging solo as they derive their energy from within. This had been my experience, and I used to fight it.

I now embrace this aspect of myself and cater to it. I lovingly nurture myself by declining the invitation to the night events at conferences. Friends and colleagues often cajole me with, "Come on, it will be fun; we only meet once a year; it's just one night."

"I'm sure it will be fun," I say. "I'll see you in the morning."

Midday at such conferences, I'll now often skip the group lunch and take a walk outside or grab a quick cat nap in my hotel room to boost my energy for the afternoon. I know what I need to feel optimal and I now honor that. How freeing it is to fully own aspects of our personality instead of fighting them. No longer do I feel shame for being in the introvert box.

closets 2

My parents made it clear to my sisters and me that being gay was not normal. They didn't understand it, thought it was a choice, and told us they didn't care what other people did as long as "those people's" behavior didn't impact our family. Not many kids I knew came out as gay in the 1970s, so while I had some gay friends, I didn't know it at the time. My parents did not like my sisters and me going to friends' homes of divorced parents, and I certainly would not have been allowed to go to the houses of gay friends if any of them had come out.

Fast forward, and my older daughter is in ninth grade.

"Welcome to Moe's!" I heard boisterously yelled at me as I opened the door to the popular teen Tex-Mex fast-casual hangout. The sound and aroma of chicken sizzling on a hot grill filled the air. Eating burritos at Moe's had become a ritual of my daughter and me while we waited for my other

daughter, Elena, to finish her piano lesson down the street. Sliding into our favorite booth, Maria told me about a girl at church she liked. They had been singing in the Sonlight choir together.

"Yeah, Lisa is really nice. I like her too," I said, taking a bite of my burrito.

"No, Mom. You don't get it. I *really* like her."

"Oh. Okay," I replied as a sliver of lettuce fell from my lips. "You mean like, like her like her?"

"Yes. I like Lisa like that."

To say I was surprised would be an understatement. Completely blindsided; I had not seen this coming. At fourteen years old, Maria had only shown interest in boys. In fact, she had recently broken up with a boy, a senior at her high school, with whom she shared drama class.

Although I was not well-versed in how to handle such an impromptu disclosure, I knew I wanted to support her.

"That's great, Maria. Does Lisa like you?" I asked, casually dipping a tortilla chip into our bowl of queso.

"I'm not sure. I don't think she knows if she's gay or not."

"I can understand that might be complicated then."

"Yeah. I know." Maria sighed and stood up. "Want a refill on your Diet Coke, Mom?"

As we walked back to the car, I was in shock. I berated myself for not sensing my own child's sexual orientation. Sadly, my immediate concern was how my parents were going to react to Maria's news. Knowing their stance on homosexuality, I'd be crushed if they made my daughter feel less than, dirty, or unworthy due to her sexual preferences.

A few months later, I braced myself for a difficult conversation.

"Mom," I said after she picked up the phone. "I have something I need to tell you."

"Okay," my mom said hesitantly.

I took a deep breath. "I'm going to tell you something, and it's important to me that Maria feels supported. Okay?"

"Okay."

"Mom, Maria thinks she is gay. I know she's dated a few guys in the past, but she thinks she prefers females, and I need you to support her."

"Well, okay then."

I waited, thinking more was coming. I heard her voice in my head. All the negative comments she'd spoken in the past about same-sex couples. She couldn't possibly be done.

"Is that all you have to say, Mom? How do you feel about this?"

"Betsy, I will always support my family. I'm fine with whoever Maria chooses to date. When can I meet her girlfriend?"

A few months later, Maria started dating a girl in her class. My mom texted and asked if she could take them both to brunch at The Flying Biscuit, a favorite neighborhood restaurant. After brunch, my mom called to tell me how lovely Jackie was and how happy Maria seemed. A week later, my mom texted Maria asking what she could bake for Maria's next Gay Straight Alliance Club meeting. Years later, my mother continued to ask about and support Maria's girlfriends and current fiancée. It has been beautiful to watch the transformation of my mother's hard stance toward people in a box different from her own and how she has embraced and loved my daughter in the box she is in.

good daughter

My mom's dad died when she was eleven and away at summer camp. She was called home to attend her father's funeral with her mom and two sisters at her side. For reasons unbeknownst to anyone still alive, my grandmother did not care for my mom, even putting coal in her stocking one Christmas when she was young. The next several years after her father's death were tumultuous ones, and my mom was sent to live with friends while her sisters stayed at home with their mother.

When my mom started her own family, she was determined to provide the structure and stability her childhood lacked. She ran our house like the military, ruling more by fear than affection, and my sole goal in life was to make her proud. She set high standards, and my sisters and I rose to the occasion. Our rooms were tidy every morning, and our clothes were clean and coordinated. Every morning, I made

my twin bed perfectly, forming hospital corners with my bubblegum pink sheets and thin blue blanket and smoothing my white flowered bedspread on top. If I came downstairs in clothes my mother didn't like and was told to change; I did so obediently.

Routine was paramount in our house. Until I was eight, every morning, my sisters and I waited at the end of our sunflower yellow Formica kitchen counter in line while my mom brushed our long brown hair, sectioned it in two, and braided it. Family breakfast was at 6:30 a.m. sharp at the round white kitchen table with lemon-yellow swivel chairs. Family dinner was at 6:00 p.m. sharp in our formal dining room around our long rectangular brown pecan table. My mother lit candles every night and plated home-cooked food for us at every meal. We had assigned seats that rotated every Sunday along with our chore list. On Saturdays, my sisters and I cleaned the house, did yard work, and participated in sports. Sundays were "family day," a day of rest and worship—no work, no friends over. Sunday breakfasts were hot—French toast or waffles; Wednesday mornings were pancake days, and the rest of the days were cold cereal and orange juice. Sunday dinners were always Italian, usually homemade pasta.

On Wednesday and Sunday nights, we washed our hair. We were allowed to watch one hour of TV and spend fifteen minutes on the phone each day. When I was a teen, I had a strict curfew, earlier than most, and could come in any time before curfew but a minute late, and I was grounded for a month.

My mother's value rested in what others thought of her children, so my appearance, performance, and career goals were of utmost importance to her. I was expected to look, act, and behave a certain way. A narrow margin of error was tolerated. My mother worshiped Emily Post's rules of etiquette

like she did her nightly prayers, and I was made to follow them. I knew how to set a table, use the appropriate flatware, shake someone's hand, and write a thoughtful handwritten thank-you card before using the gift by the first grade. The word "should" was the most spoken verb heard in our home.

My status of being a "good girl" was dependent on whether I did something my mom agreed with or liked. I wanted nothing more than to be praised for being a good girl. The very notion of "being a good girl" implied that I wasn't one inherently, so I was always striving to become one. I lived on eggshells, in constant fear that I would disappoint my mother and be a bad girl.

I first learned of my mom's "list" when I was five. She was on the phone in the kitchen, the one attached to the wall, one day, talking to a woman she played tennis with.

"I just cannot believe Sheila did that. She is so inconsiderate. She's on my shit list."

"Mom," I asked when she had hung up the phone, "what is a shit list?"

"Oh, nothing, honey. It's just a list of bad people."

Never fully understanding what got a person on her shit list, I was acutely aware no one ever came off. I was raised by a mom who believed people were either good or bad. My biggest fear was landing on this list, for that meant I was bad and could never be good again.

Because I lived in fear of upsetting my mother and getting on her shit list, most of the time, I kept my thoughts to myself.

The main disagreements between my mom and me happened when I got frustrated and pushed back at her suggestions,

opinions, or behavior. One Sunday, my sisters and I were at Mass with my parents. I noticed my grandparents, who lived next door to us, were in the same service, sitting two aisles over under the tall stained-glass windows streaming in the bright morning light.

"Mom, there's Grandma and Pappap," I whispered to her, pointing at them.

"*Shhhh*, Betsy, we are in church."

"I know, but I need to tell them we are here so we can all sit together."

"No. You can't go. You need to stay here with me."

"But, Mom, we can't let them sit by themselves."

"This is my time with my family, and I don't want to share it. Be quiet and pray, Betsy."

After church was out, I told my mother how unfair I thought it was that she forbade me from asking my grandparents to sit with us during the service. I watched as she took out a piece of gum, started chewing it, and then snapped her gum, pausing to respond. "Betsy, I told you in church, Mass is my family time and I don't want to share it with anyone." I heard another annoying crack of her gum and the sound of a bubble popping.

"Betsy, this is not up for discussion. You should be ashamed of yourself after all I do for you. Go to your room when you get home. I'll let you know when you can come out."

At the time, I did feel shame, as it was one of the few feelings that was acceptable in our home. Now, I look back and appreciate the courage it took to trade a seat in the good daughter box for calling out behavior that went against my values.

My mother's shaming tactic was not limited to complaints I voiced with her but extended to issues I raised with my father as well.

At the family dinner table, my father would try to engage my sisters and me in conversation.

"How was your day, Betsy?"

"Great."

"Tell me about it."

"I had a test in Anatomy, the one you quizzed me on last night, and I got an A. Soccer practice this afternoon was awesome. We got to do my favorite forward passing drills, and then we scrimmaged the JV team, and I assisted in two goals."

"That's great to hear, Betsy. And how was soccer practice?"

What? Hello? Are you not listening? I thought as a teen.

After weeks of feeling like Bill Murray in *Groundhog Day*, I mustered up courage.

"Dad, while it's nice you ask me questions about my day, I'd prefer you not if you are not going to listen to my responses. Your follow-up questions clearly indicate that you are not listening, and I'd rather you not ask me questions in the first place."

My mother, putting food away in the kitchen, overheard our conversation and came barging into the dining room. Exploding, she told me how ungrateful I was and that I should be ashamed of myself for suggesting my father was anything but attentive, given all that he did for me, my sisters, and our family.

In these types of situations, where I jeopardized my space in the good daughter box, my mother liked to remind me that I had a roof over my head, a warm bed to sleep in, and food on the table when children in Africa had none of these things. As a kid, I never followed what children in Africa had to do with what was happening to me in our home in Florida, but learned quickly to stay quiet and do what I was told. While I understand now this was a reflection of my

mom's insecurities and a deflection tactic to avoid discussing real issues, I willingly exchanged my emotional development to stay in the good daughter box and add more shame to my overflowing bucket.

good mom

From the time I was a little girl, I knew I wanted a family. I also knew I had no desire to be a stay-at-home mother. I babysat a total of one time in my youth. The toddler who lived across the street was sleeping soundly when I arrived, but the minute her mom left, the girl woke up screaming. I tried rocking her, feeding her, holding her, and playing games with her. Nothing soothed her. I took her outside to play on her swing set and then for a walk down the street, but nothing would console her. Three hours later, we were both exhausted as her mom pulled into the driveway. I walked home, vowing never to babysit again.

The next time I was alone with a child, I was thirty years old and holding my own. I had been married for seven years and

had an established career in the pharmaceutical industry. I had switched jobs every few years, moving up the corporate ladder and closer to home with each move. By the time I had Maria, I was working a mile away from our house.

It was only after I had my daughter did I get a glimpse of the "good mother" box and learned my career prohibited membership in it. After delivery, I took advantage of the Family and Medical Leave Act granting twelve weeks of maternity leave to adjust to motherhood, bond with Maria, and establish friendships with other moms of young children. During this time, other new moms frequently asked what my plans were for work, and I told everyone I was returning after my leave. While I very much loved being at home with my daughter, I knew I wanted to, had to, work. I'd been working formally since I was fourteen and informally since I was eight. I loved working and the stability it provided for our family. My work did not require overtime or much travel, and I worked so close to home that I came home for lunch almost every day. But every mom in the play groups I had joined was staying home.

One morning at my daughter's Gymboree music group, I was talking to other moms.

"Aren't we lucky we get to stay at home with our babies?" Sarah said.

"Yes, I've really enjoyed my maternity leave. It's coming to an end in a few weeks," I said with a sigh.

"Really? You are going back to work? How can you leave your precious baby?"

I could feel the blood rise to my face as I started to feel defensive. Was Sarah really questioning my decision?

Judging really. I felt grateful I even had a choice, as many single parents don't.

"Oh, we don't want to put her in daycare, so my husband is going to stay at home with her," I responded curtly, thinking I'd ended the discussion.

"I admire you. I really do. I just could never do that. I care about my baby more than my career," Sarah retorted.

Since when did working mean my career trumped my family? Couldn't I have both? I knew many successful career women with great families and well-adjusted kids. Choosing a career did not mean I prioritized it over my children. It meant I envisioned a world in which they could coexist and thrive together. This was not a zero-sum game. Like two trees that appear separate above ground, but upon closer inspection, we see their root systems intertwined, supporting each other. They thrive because, while seemingly siloed, they are beautifully enmeshed.

After three months of maternity leave, my guilt, breast pump, and I went back to work. To say I didn't feel guilty going back would be a lie. I read a study that showed people (both men and women) rate mothers who go back to work as less committed to motherhood and more selfish than unemployed mothers. My mom and grandmother had been stay-at-home moms. Many of my friends had made the same choice. My twin sister left her career as a physician when she had her first child a year before I had mine. The guilt ebbed and flowed, and Sarah's comment echoed in my mind whenever I had an issue with one of my children as they grew. I'd question, "Is this happening because I went back to work?"

Two years later, after having a second daughter, I entered yet another box—the divorced working mother. In this box, I was told by a friend and neighbor that I didn't value my marriage, even though I wasn't the one who'd stepped out of it. In addition, not eligible for alimony; the choice to work or not was no longer mine.

The "good mom" box can be insidious. One of my closest friends, a divorced working mom, has been passed up for several promotions because of her divorced status. She says her boss has stated she cannot be a dedicated professional with a solid career and be a divorced mother because she has too much on her plate as a single parent to be fully dedicated and effectively manage both. Meanwhile, my friend has watched several divorced fathers pass her in the promotion line.

I fortunately chose to switch careers and become a Realtor when I got divorced. This allowed me to work from home and gave me flexibility in my schedule to drop off and pick up my children from school every day. Now that my girls are in their twenties, I see the value they received in seeing their mom work to build a business and support our family. In addition, they worked as my helpers throughout their childhood. They were my fulfillment center, stuffing and licking envelopes for mailers and working events with me. They tagged along to showings and closings. When I opened my own brokerage, the three of us voted on the company logo and font to use for the new business. They stuffed eggs for our annual community Easter Egg Hunt, worked client appreciation parties, and came to company meetings. As I saw how helping me become successful in business was as valuable to my daughters as what they were learning in school, my guilt dissipated, and I grew more confident that my career didn't exclude me from being in

the "good mom" box and, in fact, may have solidified my seat in it.

As much as I strived to be in the "good mom" box, I understand how the "good mom" box affects women who make the decision to go through life without having children. How many times have Oprah Winfrey, Jennifer Aniston, or Ina Garten been publicly questioned for their decision to be childless? The implication is this is not normal or that they haven't reached their full potential, falling short of some unwritten standard. Jennifer Aniston defends she can still be a good mom to her animals, nieces and nephews, and other people's children. It's sad she feels the need to defend her life decision. Gloria Steinem believes "Everyone with a womb doesn't have to have a child any more than everybody with vocal cords has to be an opera singer,"[9] while actress Marisa Tomei questions the attitude, "I don't know why women need to have children to be seen as complete human beings."[10] Also, why don't we hear Jay Leno, Keanu Reeves, and Seth Rogen having to publicly defend the same choice these women made?

good mom 2

When my daughters started school, I learned about other criteria in the "good mom" box. I learned quickly that judgment around parenting decisions ran rampant. Raising my girls, I turned to countless parenting books to help me navigate the best way to raise them.

From the beginning, I let my children pick out their clothing. If they wanted to wear mismatched clothing to school, I let them. If they insisted on wearing shorts when it was cold, I let them. If they insisted on wearing costumes or pajamas out, I let them. Clothes inside out? Fine. I decided early on I was going to fight the big battles and not be worried about what my children were wearing. I also wanted them to be able to experience freedom of choice and expression. Elena loved wearing her shoes on the wrong feet. I'd let her know they were on opposite feet, and often, she would grin and tell me she knew. She loved clothing and often wore

outfits not meant for the occasion. Swirly dresses for a play-date at the park, her pink princess dress to church. For one entire year, it was rare to see her without her sparkly silver tiara adorning her head.

While taking a hands-off approach to their external appearance, I was the opposite when it came to my daughters' education. When Maria started kindergarten, I quickly signed up to volunteer weekly in her classroom. I wanted to experience the environment where my child spent her days. I wanted to know her friends and the school staff. I wanted her teacher to know I was an active participant in my child's education and wanted to pave a pathway of success for my daughters. In kindergarten, I knew when every quiz was, would test Maria before each test, check her homework, and have her redo anything she missed. Sometimes, I'd look ahead and make sure Maria was prepared for topics coming up. On the rare occasion when she forgot her homework, I drove it to school.

Moving on to first grade, Maria was assigned her first real project. She had to pick a famous person who had made a difference in the world. Maria chose Rosa Parks. She checked out a few books from the school library, and we went to Michaels and meticulously selected craft supplies for the poster she was tasked to create. The next weekend, we labored over her project. I drew light lines all over the board, mapping out where each picture, each square of text, and each object was going to lie. Once I had everything placed beautifully, I handed Maria a glue stick and told her where to place the paper on the board. If it landed a little off-center, I fixed it. I spelled out the titles for each section, and she copied them over the lines I had predrawn on the poster board. Then, I erased the light lines I had drawn so Maria's writing floated perfectly straight across the board. By Sunday

evening, we had a masterpiece, and I proudly walked it into school early the next day.

When I entered Mrs. Walton's classroom, other kids were coming in behind us. I saw the posters they were lugging in. Some were crumpled, some had eraser marks all over them, slanted pictures were pasted on at odd angles, and titles were misspelled in sloppy, sloping handwriting.

My initial reaction was sadness. Why didn't these kids' parents help their children, guide them, and correct them to ensure they turned in a perfect board? After a few minutes, my sadness turned inward. I saw how proud these children were of their posters, anxiously waiting their turn to show Mrs. Walton. They had clearly done their projects by themselves, and they were filled with pride. It was obvious Maria hadn't done hers on her own. In fact, it looked more like a poster a high schooler would turn in, not a first grader. I felt awful for what I had done to Maria and was embarrassed by my behavior.

I walked back to my car, weighted down by my actions. In trying to provide a supportive environment for my daughter, I was doing the opposite. I questioned my true intentions. I wanted Maria's teacher to like my daughter and to know she came from a home with an involved mother.

But what message was I sending to Maria to get my egoistical needs met? If I was "helping her" do her project, I was sending Maria the message that she was incompetent to do it on her own. This was the opposite of what I wanted. I wanted to raise daughters who were secure, confident, and independent. I vowed that day to stop everything that sent an enabling message I didn't want to convey. I asked myself, what is my long-term goal in parenting? To raise children who know they can do things on their own. Who were confident in their abilities. Who were resourceful and

imaginative. Perfection and what a teacher thought of me were not my ultimate goals, so I needed to stop acting like they were.

That night, I went cold turkey. I stopped assisting my children with their schoolwork. I stopped checking their homework and what was due when. Before doing anything for my children, I'd ask myself, "Do I want to be doing this for them in ten years?" If the answer was no, I stopped doing it and showed my daughters how they could do it on their own. The day after Maria turned in her Rosa Parks poster, I showed my girls how to do their laundry and how to pack their lunch boxes. I stopped quizzing my daughters on upcoming tests. I stopped checking their homework and only asked if they had completed it. If they had a project due, my only involvement was telling them they had to give me a list of supplies they'd need a week before it was due, or else they'd have to use what was in the house.

A few years later, I asked one of my friends, Mary, if she could join a group of us for dinner on an upcoming Saturday night. Mary declined, saying, "We have a report due Monday."

"We?" I asked as I knew Mary to be a stay-at-home mom.

"Well, Todd has a project due, and I need to stay home this weekend to help him."

Two weeks later, I saw Mary coming out of school. She looked upset, almost in tears.

"What's wrong?" I asked.

"Remember that project that was due two weeks ago?"

"Yes, we missed you at dinner that night."

"Well, Mrs. Stevens gave me a 'B.' Can you believe that?"

"Wasn't that Todd's report?" I asked gently.

"Yes, but I practically did it for him. I have a college degree, and she gave me a B. I just can't believe it."

While I felt bad that Mary was taking it so hard, I was grateful I had changed my ways years before, even though it had kicked me out of the "good mom" box.

It was also during this time that I read many John Rosemond parenting books and aligned with his philosophy on discipline and the idea of natural consequences. If my daughters' homework was left on the counter, it stayed there until they remembered to turn it in. The first few times this happened, the teachers gave them As on their late homework. One afternoon, after seeing another A come home on late homework, I called the school and asked to speak to the teacher.

"Mrs. Smith, Maria just showed me her homework. How did she earn an 'A' on the latest math assignment?"

"Ms. Pepine, Maria is great in math. She had all the answers correct."

"Yes, but she turned it in a day late."

"I know, but she's a good kid, and it doesn't happen often."

"I appreciate that, Mrs. Smith, but how is Maria going to learn about consequences if there are none? Accountability is a more important skill for children to learn than arithmetic, Mrs. Smith. Please hold her accountable."

When my girls forgot their lunch, I no longer ran it to school. If they asked me for help on something I knew they could do on their own, I'd say, "I know you. You'll figure it out."

This change was one of the most difficult things I have done in my life, yet it was one of the best decisions I ever made. I was criticized by some friends and teachers for being harsh. At times, I thought I was channeling my mother, seeing the benefits structure and clear expectations brought.

When my daughter Elena stole a snack from a friend's lunch box in third grade during recess, we discussed why it was wrong to take something that didn't belong to us. Elena explained that she had wanted the candy in her classmate's lunch because she didn't have any (I didn't put sugar-laden foods in my daughters' lunch boxes). The second time she stole a snack, she was grounded for a week. The third time, upon picking her up from school, instead of driving her home, I drove her to our county prison for a tour of where she'd go if she continued her pilfering. Natural consequences. Elena didn't steal again.

If one of the girls slammed their bedroom door, the door took a timeout in our garage for a month. If my daughters were bickering in the car and I had already asked them to stop arguing, I stopped the car and told them to get out. The first time I did this, they thought I was kidding. We were a mile from home. I explained that I deserved the right to drive in peace, and because they chose to keep fighting, they needed to get out of the car. (Of course, I circled back and slowly drove behind them, watching them the whole way home.)

Once in middle school, I was having a particularly hard time with Elena. Natural consequences were not working, and she wasn't bothered by anything I took away. Then it dawned on me that the one thing she did care about was her clothing. That afternoon, when Elena came home from school, she found three outfits on her bed.

"What's this?"

"Those are the outfits you can wear for the next month."

"What do you mean, Mom?" Elena said in a raised voice as she walked to her closet. Opening the closet doors, she saw empty rods and bare shelves.

"For the next month, these are the three outfits you can wear. You can mix and match them to make others. Just remember to wash them when they get dirty," I said.

"Mom, you cannot be serious. There are five days in a week."

"Yes, I am aware. You'll figure it out."

The next day, my cell phone rang while I was showing houses to an out-of-town buyer. Recognizing the school phone number, I picked up.

"Hello, Ms. Pepine, this is Ms. Cook, Elena's guidance counselor at school."

I froze. I'd never talked to a school guidance counselor before.

Pointing at the door, I silently mouthed to my client that I needed to step outside the house for a moment.

"We've never met, Ms. Pepine, but Elena came to see me this morning. She says there are problems at home."

"There are no problems, just normal adolescent behavior, and Elena does not like some of the consequences of her actions."

"I see. I know this age is difficult. *Umm*, she mentioned you took away her clothes. That can't be true, is it?"

"No, that is not true. Elena has three outfits she can wear to school."

"Doesn't that seem extreme, Ms. Pepine? She only has three outfits to wear?"

I was dumbfounded by her brazen inquiry. When did disciplinary issues at home become fodder for discussion by school administrators?

"Yes, she has three outfits to wear, and, no, that does not seem extreme. Ms. Cook, given that Elena's gifted program resides in the poorest school in town, I am sure there are many economically disadvantaged students at your school with only three outfits to wear. Elena is one of them."

"Well, I know you are only trying to be a good mom, but I disagree with your disciplinary methods, Ms. Pepine. I'm going to discuss this with the staff, and someone will call you back."

I never heard from the school again, and Elena's behavior quickly corrected itself.

My daughters are now thriving twenty-five- and twenty-six-year-old women—confident, independent, and making a positive impact on the world through their work and relationships. Just the other day, Maria and I were discussing an issue she was having at work.

"What are you going to do about it?" I asked.

"I don't know, Mom, but I'll figure it out."

I smiled, knowing the parenting goal I had set out years before had been accomplished even though many, including myself, had questioned my seat in the "good mom" box along the way.

good mom 3

've shared my house with furry four-legged companions for as long as I can remember. We got our first family dog, a black Labrador that we named Dandy when I was six. My sisters and I adored Dandy, but my mom quickly realized she would be the one taking care of her and that a puppy was too much for her. On the day my mom returned Dandy to the breeder, I experienced my first real loss, and I hyperventilated from crying so much. A few years later, we tried again with an older dog. Penny was a rambunctious Beagle rescue we found in the newspaper. Week after week, we'd find Penny running down the street after scaling the fence in our backyard. Soon, my mom decided she, too, had to go, and my hyperventilation returned. A few years later, we went back to black Labradors and adopted Nellie from the local sheriff. Within days, she was scrambling to bring in the newspaper every morning. Sundays were the hardest for her

because the paper was bulging with all the weekly ads and coupon inserts. Sometimes, Nellie would have to make a few trips down the driveway to get all the sections in. Her favorite command was "slipper," which had Nellie running up the stairs and down the hallway to my parents' bedroom to bring one slipper down to my mother, who had her feet up on the oversized brown velour ottoman in our living room. We had to tell Nellie "slipper" again to get her to bring the second slipper down as she couldn't hold both in her mouth at the same time. Soon, Nellie would be waiting for me, her strong tail thumping our sidewalk when I got home from school to go on our daily run. She reminded me of Velcro as she liked to run right next to me, our feet almost touching, causing me to look down constantly, careful not to trip over her.

Seven years flew by, and I went off to college, sad to leave Nellie behind. Early in my first semester, I was on the hall phone calling my parents for a weekly check-in.

"Betsy, I need to tell you something," my mom said.

"That sure doesn't sound good."

"I found Nellie a new home."

"You WHAT?"

"I found her a new home. I just couldn't do it anymore."

"Do what, Mom? No. I'll come get her," I said desperately. I was coming home for fall break in two weeks and would bring Nellie back with me. My roommate loved dogs.

"The dorms don't allow dogs."

"I'll move then."

"With what money, Betsy?"

I hung up the phone and threw myself on the bed, sobbing again uncontrollably. Nellie was a part of our family. I

could not fathom giving her away. I vowed then to get my own dog as soon as I was out of school.

A few months after graduating from business school, my fiancé and I volunteered with The Seeing Eye, a non-profit organization in Morristown, New Jersey, that raises guide dogs for the blind. We signed up to become foster parents for their puppies' first year and a half, as The Seeing Eye recognized that dogs have better outcomes when their formative months are spent in a nurturing home rather than at their center.

Because we both had female black Labradors as pets growing up, we requested the same for our first dog. Idona arrived at our door a month later, at ten weeks old. We instantly bonded, and Idona went with us everywhere, in part because The Seeing Eye wants their puppies to be exposed to a wide variety of environments, smells, and people and in part because we couldn't bear to be without her. I took her on a run every morning, and she quickly claimed the passenger seat in any car we drove. Idona even went on the school buses we bought for a job we had shuttling kids to and from school at an army base nearby and, in downtime, would sit on the hood of the buses waiting patiently for us. We spent weekends at the beach with Idona, chasing kites and swimming after frisbees until she was so tired we had to put her in a wagon to wheel her back to our beach condo.

Six months later, I began dreading the commitment we had made to give Idona back to The Seeing Eye when she reached a year and a half. I could not fathom the thought of having to let her go. I lost days of sleep the month leading up to Idona's return date. Two weeks prior to the date, I called The Seeing Eye in desperation, asking to purchase

Idona, but they said that was not possible. "I'll pay anything," I pleaded, but the answer was an emphatic no.

Her year and a half with us went by all too quickly, and I watched from the living room sofa, holding Idona tightly, as The Seeing Eye's white van slowly pulled up to our house. My body trembled. I could not process that this was the last time I was going to hold my baby girl. Similar to the agony felt perhaps by biological moms in closed adoptions, the only future connection I had was an invitation to observe Idona from a distance on her graduation day from The Seeing Eye. Other than that, no contact with her or her future owner was allowed. My then-husband and I walked Idona slowly to the van, and I held her one last time, whispering in her ear that she was loved and that I would always be thinking of her. I lifted her up and placed her in the black sterile crate in the back of the van, tears streaming down my face. The back of the van door closed and I watched the van slowly pull away, down the street and out of our neighborhood, dragging with it my heart.

The next few weeks were gut-wrenching. I had never felt such loss and grief. I crawled into work every morning, barely functioning, and then crawled into bed as soon as I got home in the evenings. I tried running again, but without my loving companion beside me, I had no motivation. As the month passed, I started to feel a slight shift in my grief. The ache was still there, but I could smile without sobbing when I thought of Idona. I was finding peace and gratitude for having gotten to be Idona's mom for the first year and a half of her life, and even in my pain, I knew I'd do it all over again.

A few days later, I was at work, and my desk phone rang.

"Hey, Bets, it's me." My husband was calling. My husband never called me at work.

My mind raced. "Who died?"

I heard a sigh. "No one died. But I have good news, and I have bad news. Which do you want first?"

"Bad news," I said curtly, annoyed he had to ask.

"I just got a call from The Seeing Eye."

"What happened to Idona?" I steadied myself, bracing my arms against my desk as though I was on the edge of a cliff, knowing that I was about to fall but not knowing how far or how hard the landing would be.

"She failed out of their program. They are not going to be able to use her as a guide dog."

"What? Why?" We had spent the last year and a half religiously attending The Seeing Eye's meetings and training sessions, teaching her their numerous commands, and checking off all the places and things we had to expose her to to ensure she would be prepared. I had prided myself on how smart she was and how quickly she learned new things. How could she possibly have failed out of their program?

"Something about her hips. Not strong enough to hold their heavy harness."

I knew The Seeing Eye required dogs to wear a heavy leather harness during their ten years in service, but I had never seen any issues with Idona's hips.

"She's healthy. Just won't be able to assist a blind person."

"So they want to use her as a therapy dog instead?" Frustrated with all the details and seemingly no positive news in sight, I knew harnesses for therapy dogs were much lighter, being made out of fabric.

"No, Bets. Now, the good news. We have the right of first refusal."

"For her to be a therapy dog?" My brain was not under-standing what that meant.

"Betsy, they are asking us if we want Idona back."

A loud thud startled me, and I looked down. "What did you just say?" I said before I even reached down to pick up the phone I had dropped.

"We are picking Idona up Friday."

Three days later, we arrived at The Seeing Eye headquarters in Morristown, New Jersey, for our designated pickup. We waited in the lobby for someone to come out and greet us. A few minutes later, I saw the brown wood door across the waiting room open slowly, and a big ball of black fur burst toward us. Idona leaped over the lobby coffee table and into my arms. I nuzzled into her neck, breathing her wonderful scent into me. Other than having shed a few pounds, she looked the same.

Idona lived a very long and happy sixteen years with us. When my husband and I divorced, she lived with me and the girls, but my former husband had weekends with her, too, often taking her to her beloved beach where she could freely chase birds and kites.

When she was fifteen, her hips weakened, so I bought carpet runners and put them all over our wood floors for better traction. As her stability worsened, she wore booties on her paws for extra friction. Around this time, one of my neighbors, who also adored Idona, came over to the house.

I opened the front door and saw Joan standing on my porch.

"I don't want to be the one to tell you this, but it's time you put Idona down."

Dumbfounded, I tilted my head and stared at her. What did she just say?

I had not asked her, nor did I question her decision when she took her dog to the vet, only to return home without him. Her dog had been diagnosed with cancer that day, and she hadn't wanted to see him suffer.

"Joan, neither you nor I will determine when Idona's time has come. Only Idona will know, and she will tell me." Annoyed, I shut the door in her face.

Six months later, Idona lost her ability to walk but not her zest for life. I would carry her outside to enjoy the sun, and she loved the wagon rides my girls and I took her on. She also enjoyed being in our presence on her comfy bed in the center of all the family action. One day, the husband of the neighbor who had come to speak to me prior charged up my driveway while Idona and I were outside enjoying the sun. He was standing two feet away from me when he demanded, "Why are you doing this, Betsy?"

"Doing what?" I asked.

"Keeping Idona alive. This is abuse."

"John, just because you find it inconvenient that Idona can no longer walk, I do not. As I told your wife, Idona will decide when it's time to go, no one else."

A few months later, I woke up one morning and looked down at Idona on her bed. Something had shifted. I crouched down and looked into her eyes. She met my gaze. Overnight, her eyes had changed. They were distant, vacant. I held her tight and knew she was telling me it was time.

Idona's passing was one of the hardest things I've ever endured. She had been with me long before I had children

and long after I got divorced. She and I had shared so much of life together. A part of myself left with her that day and a part of her has stayed within me. While others tried to push me into the "bad mom" box, I am confident Idona left this earth on her own terms when she was ready.

boards

I have a vision board hanging on my wall in my office at work. Every January, my employees, real estate agents, and I have a company-wide visioning meeting where we evaluate different areas of our lives, from health to finances to relationships and hobbies, and make goals for each. We spend time creating vision boards, a physical representation of these goals. We then share what we have manifested the previous year and what we are adding to our vision boards this year. Some of us remove the pictures of what has come to fruition, while others transfer these pictures of accomplishments to a second "fruition" board as a reminder of how far we've come.

After a vision meeting a few years ago, I decided to use a photo of my board as my screensaver on my cell phone and desktop computer. This forced me to see, several times a day, what I wanted to bring into my life. I was confident that, in time, all things on my vision board would manifest.

One of the images on my board that year was a picture of a group of business professionals in dark blue and black suits around a large conference table. This picture signified to me a quarterly board meeting at a bank where I was a member of its prestigious board.

Fast-forward a few years, and one day, I saw a missed call on my cell phone. The voicemail was from Keith, a local bank officer, asking if I'd ever considered being on a bank board.

"We have an opening on our board, and I'd like to discuss the opportunity with you," Keith said when I returned his call. "Are you free for lunch next week?"

I glanced up at the vision board picture of me at a board meeting, my heartbeat picking up its pace at his invitation.

I met Keith the following week. He brought the bank president, Steve, another gentleman I had met briefly a few times. Over lunch at Ballyhoo's Grill, Steve discussed the changes in the banking industry, how people were going remote, using cash less, and the role of fees to the bank's bottom line, etc. Steve also shared the bank's long-term vision and initiatives. After much discussion, he asked me if I would be interested in joining their board.

I was now perspiring and struggling to stay focused. I envisioned myself taking the faded picture of the board meeting off my vision board and tacking it to a fruition board. Trying to contain my excitement, I took a deep breath and said, "Yes, I would welcome being a member of your board. Thank you. I feel I have the skills to help the bank reach its goals and look forward to being able to contribute to its success."

Steve then turned to Keith. "Thank God," he said. "She'll be just perfect."

Steve smiled at me and welcomed me to the board. "Betsy," he said, "our board is composed of white older men. We are under great pressure to diversify. Thank you for agreeing to join us."

I felt my body constrict as if in protection mode to make myself smaller. I was stunned by the words I had just heard.

Over the past ten years, I had worked tirelessly to make a difference in the real estate community. The brokerage I had built, Pepine Realty, had been recognized locally, regionally, and nationally for the impact it had made on the community and industry. *The Wall Street Journal* consistently ranked my team among the top in the country. *Inc.* had named Pepine Realty one of the 5000 Fastest Growing Private Companies in the USA for several years. My company had earned a spot on the Top 50 Florida Companies to Watch list as well as been named as one of Florida Trend's Best Companies to Work For. I had started a 501(c)(3) non-profit that helped local at-risk families with their housing needs. I'd taught our agents how to get out of debt and how to invest in real estate so they had multiple streams of income to provide for their families.

Despite this, I was invited to join this prestigious bank board not because of my hard-earned accomplishments but because I was born with a vagina. And, more importantly, now Steve could check his diversity box.

Like a deer in headlights, I quickly ran through my options. I could decline the invitation and not accept the handout, or I could accept the invitation and hope to be an inspiration to my daughters and other women in the business community. "Thank you, guys. I accept. And, the first thing I'd like to change is how we make and announce our

board decisions. We undermine a person's credentials if we tell someone the position is being offered to them because they check a box."

buy box

There is a term in real estate called the "buy box." The buy box is a list of criteria a buyer has when looking for a property to purchase. One buyer may be looking for a three-bedroom, two-bath, two-car garage home with a pool on one to five acres within ten miles of the city center under $450,000. Another buyer's criteria may be the complete opposite. Our brokerage offers an instant offer program where we will buy an owner's house if the property meets our criteria. The buy box for our program includes the following:

Alachua, Marion, and St. John's Counties
Single-family – attached or detached
$100-$500K market value
On one acre or less
Reasonably good condition
No sinkholes or flood zones
Seller must be current on property taxes and mortgage

We know homes with these criteria generate a more reliable return. Anything outside the buy box is not eligible for our program. While a very simple idea, the buy box takes the emotion and feelings out of a decision. We may fall in love with a home's curb appeal or the custom-carved handrail of the staircase, but when we refer back to our buy box, reason takes over. Buy boxes keep us grounded when we fall in love for other reasons.

I found the buy box concept so useful that I created buy boxes for my personal relationships. My Friend buy box criteria includes shared core values: Do they live with integrity? Can I trust them? Are they receptive listeners? Do they have empathy for others? Do they show introspection? Is there depth to their thinking? When I meet someone and get a hint of these green flags, I know I may want to get to know them better.

My Romantic Partner buy box includes additional criteria: Are they looking for a long-term commitment? Are they loyal, authentic, health-conscious, growth-minded, or dog lovers? When a relationship ends, I review my buy box and make revisions as my needs have often changed or the relationship brought to light other criteria I need to make my next one more satisfying. I recently added "stable attachment style" and "ability to make me laugh" to my Romantic Partner buy box.

My buy boxes have made it easier for me to evaluate relationships more objectively and learn from my past. After dating Adam, the man with an affinity for prostitutes, I added addiction-free to my buy box. Buy boxes have also allowed me to recognize green flags more quickly. When meeting a potential new friend, I now know exactly what I am looking for. I know what could likely become a meaningful relationship and what will likely not be fruitful to pursue. Creating buy boxes has provided me with more intentionality and purpose in my relationships, making them richer and more meaningful.

they/them

My daughter Maria dated a lovely woman shortly after college. The first time I met her, we had brunch on a rainy Sunday morning at the cozy café Bubby's in lower Manhattan. Amy dressed impeccably and was polite, intelligent, and well-spoken. I noticed Amy was flat-chested and sported men's clothes—a pressed collared dress shirt with buttonholes on the left-hand side, black suit pants, and men's tan dress shoes. She wore her jet-black coarse hair in a short buzz cut. We had a delightful meal and an interesting conversation and then departed.

A few months later, Maria told me that Amy had decided to use they/them pronouns and asked that I honor that. Not knowing much about nonbinary identity, I checked out a library book to learn more. Growing up in the 1970s, our sex was synonymous with our gender. We were labeled male or female. Occasionally, we'd hear about folks born

with ambiguous genitalia, but for the most part, we were put in a male or female box at birth and didn't deviate from it. Preference for sexual partners was starting to become more fluid, but sex assigned at birth and then lived out was the norm. It was also a box I never considered "a box" until recently, as I have never struggled with my identity or felt my body did not match me.

I felt immediate empathy for Amy, and wanting to respect her wishes, I started using they/them pronouns with them. It was hard at first because I'd never been asked to do this and had no practice, but over time, the pronouns rolled out naturally.

A few months later, on a phone call with my other daughter, Elena, I learned of Frank.

"Maria and Frank saw the Broadway show *A Play That Goes Wrong* last night and loved it."

"I loved that play, too. The pre-show was hysterical. Who's Frank?"

"Oh, did I say Frank? I meant Amy," Elena said.

Hearing a waver in her voice, I wondered if my lesbian daughter was now dating a guy.

"Elena, who's Frank?"

"I didn't realize you didn't know, Mom. Maria calls Amy Frank now."

"Is that what Amy wants to be called?"

"Yes."

"Okay, then I'll start calling them Frank."

"Great. Except if Frank's mom is around. Then call them Amy. Their mom doesn't know."

My heart immediately tightened. As a mom, my heart went out to Amy's mom. How would I feel if my daughter was wrestling with such an important identity issue and she felt that she couldn't share it with me?

"But still use they/them pronouns?" I asked.

"Uh, no. He/him would be better."

"No problem," I said, understanding that Frank was not nonbinary but transgender.

Maria and Frank vacationed at my home over Christmas that year, and I referred to him as Frank. His shoulders relaxed, and a genuine smile came over his face as if to say "Home at last" when I addressed him. We played a lot of pickleball that week, and when I heard players unprompted yell, "Great job, Frank" or "It's his turn to serve," I could see pride radiate from his body. I was so happy for him and proud of his transition to get into the box he felt most comfortable in, a box that many of us have never had to struggle with. We each have our own boxes to navigate and carry throughout our life. But we can learn, too, from boxes we've never been in. I've never struggled with my gender identity, but my interactions with Frank allowed me to better understand gender identity issues and the hardships many endure.

closing gifts

Last year, in a TikTok video (follow me @gainesvillereal-tor), I expressed my view on real estate closing gifts. I am against them. Buying or selling a home is a life event, and most people carefully vet a licensed agent to assist them. They google Realtors, ask for recommendations, and look at reviews, as they may only go through this a few times in their lives, and much money is at stake. They want to be sure they pick a competent individual.

Having a healthcare background, in the TikTok video, I compared the real estate process to the process of getting surgery—a high-priced, high-stress life event where we vet our provider. I've had three surgeries, and I carefully vetted each surgeon. Fortunately, they were all positive experiences, yet I never once received a thank-you card or a closing gift from any of the surgeons.

I personally think gifts at the closing table undermine the professional services we provide and create a transactional feel rather than the relational connection/bond I seek with my clients, which is what I said on the video.

The comments on my TikTok video were vicious. Viewers commented on my appearance and personality: "She's so fake," "She makes it sound like her clients are beneath her and should worship her service," "You seem like a lot of fun," and "Coulda made this shorter and say [*sic*] 'I'm not considerate.'" Some assumed I was unintelligent: "Seriously, they take a few weekend courses and think they are brilliant." Others suggested I was greedy and cheap: "I bet you don't believe in tipping either." They questioned my boldness: "The audacity. You did not just compare a Realtor to a surgeon." So many comments sidestepped the actual topic of the video.

This TikTok video has received almost a half million views, my highest viewed video to date. Many questioned why I don't take it down with so much negative feedback. Through my own growth journey in, out, and through boxes, I learned that being successful and putting my ideas out into the world threatens the status quo. This makes people unsettled, so viewers attack at their most primal level. Over the years, this has happened time and again. I've spoken with numerous colleagues since this experience, and I'm not alone. Award-winning author Glennon Doyle talked of this on a 2023 episode of her podcast *We Can Do Hard Things*. She explained that when women put their work out into the world, they generally receive comments on one (or more) of four topics:

1) their appearance
2) their relationship with their spouse or children
3) their personality
4) their ambition, drive, or greed

These comments are not just made by males, but females, too, and sometimes even more so by females. Our society, both men and women, finds a driven, successful woman unsettling as she threatens the safety and security of the patriarchal society to which many have become accustomed.

I understand women who make the choice to enter the career box and thrive are often judged on everything but their work or ideas. Like actresses on the red carpet, women in business hear comments about their appearance, age, relationships, and, as a last resort, their money-driven attitude. We cannot allow feedback and comments irrelevant to our work to stop us. To be a part of the change our society so desperately needs, we must not shy away from thriving in the career box in a society that keeps our value pegged on the superficial and irrelevant.

checkmate

Boxes follow us through life. There are physical boxes that invoke many feelings by their appearance alone. The warmth of seeing a Valentine's heart-shaped box of chocolates placed on my chair at the family breakfast table by my dad every February 14. The thrill of expectant first-time parents seeing boxes at a surprise baby shower. The adrenaline of fighting our siblings to get the prize inside the cereal box. The delight of seeing colorful holiday-wrapped boxes under a brightly lit Christmas tree. The promise held in the small square ring box a partner on one knee is holding. The mixed emotions of opening the black box found after an airplane crash containing a glimpse into the final moments of lives gone too soon. The relief found in the Wi-Fi box installed in a new home connecting us to the world. The anxiety of walking to the mailbox wondering if the letter we've been waiting for has arrived. The salivating aroma from a pizza

box delivered hot to our front door. The angst in counting the names in the ballot box of a close election. The comfort of seeing a favorite flavor of ice cream in the icebox. The agonizing feeling of seeing a checkbox for a question we hoped we wouldn't be asked on a form. A heart skipping a beat upon spotting the light hue of a Tiffany Blue jewelry box. And our final box. The box of ashes or the box coffin our bodies are placed in upon our passing.

Boxes are also a part of our everyday language, used to express things metaphorically. In our training room, we have a large picture that says, "Think outside the box." In our agents' workstation room, a wall hanging suggests, "Be the brightest crayon in the box." Someone may be boxed into a corner or described as dumb as a box of rocks. Going to the theater means going to the box office. Sometimes, we find ourselves opening Pandora's Box. We may park in such a way as to box someone in. Or we may be called out as being "on our soapbox." The most likely candidate in a job search may have "checked all the right boxes."

And finally, there are the unseen boxes that evoke equally intense emotions as physical boxes but in a much more insidious way. These are the boxes of expectations our families, partners, religions, communities, and employers place upon us or that we place on others. Despite being invisible, these boxes have clear walls demarcating in or out. Sometimes, we enter these boxes consciously and willingly because they promise love and acceptance until we wake up one day so sick we are forced to ask ourselves, "Why am I trying so hard to squeeze myself into a box not built for me or by me?"

While sometimes we fight to get out of certain boxes, other boxes we fight equally hard to take up residence in because they hold the promise of love and acceptance or yield privilege, power, and prestige. People in the Student

and Senior box benefit from discounts given for their age; first responders, health professionals, and public servants often qualify for special loan terms, and veterans enjoy many benefits for their service. The "professional" box often yields power and prestige. The religious Father or Deacon box yields respect.

Part of my desire to write this book is to be able to check the box of author. I'm an incessant reader in awe of the wisdom authors have shared with me. I hope I can have the same impact on others that authors have had on me.

Why do boxes exist in our world? They exist because, at their best, they provide structure, safety, and security for those who build them. The construct of boxes helps people identify "their likes." Some people take it a dangerous step further and allow boxes to define their identity, and if their box is taken away, they are crushed. Boxes can be scary. They, by nature, separate and divide. They can create tunnel vision where we slowly and subconsciously give up agency. Or we can wake up one day realizing that squeezing ourselves into someone else's box doesn't bring us the love and acceptance we sought. We are in the wrong box.

Boxes are human constructs. Do we see animals agonize over which boxes they are in? Which boxes do they want to escape? Do we see them kill over religion, sexual preference, or race? These boxes start out as ideas, and if they take hold, informal and formal structures and systems are built to support those people who benefit from them.

Not all boxes are meant for all people and some boxes may work at one point in our life but not in others. We may outgrow the need for a box or find ourselves back in one when circumstances change. Awareness is the key. Whose norms are these boxes perpetuating, and why? Do they align with our values and where we want to be? We must recognize

the myriad of boxes we are exposed to and make conscious decisions if and when we are opting in and if and when we need to leave, for we cannot exit a box we don't know we are in.

I ask myself the following questions when I'm contemplating getting out of a box: How am I feeling? What is my body telling me? Our bodies don't lie. I try to move toward that which feels good, away from that which feels bad. Is what I'm hearing, doing, or being asked to believe consistent with my values—not my family's values, not my religion's values, not whatever "in" group's values, but MY values? Are these beliefs, actions, and behaviors leading me to where I want to be? Is this in line with my vision of me in the future? How is being in this box serving me, positively or negatively? What is the worst thing that may happen if I stay? If I go?

If I decide I want to exit a box, the exercises below help me ease the transition of my exit, knowing some exits can be done quietly with little fanfare while others may stir up a range of emotions and behaviors from myself and others. I close my eyes and envision how I will feel to be free from this box; I meditate on this until I fully embody these feelings and ask myself, *Do I feel better or worse freed from the box?* I make a list of people who could be hurt or upset by my exit and anticipate the discussion I may have to have with these people and script-loving but firm dialogue to communicate my feelings and decisions. I also plan self-care activities to help alleviate the discomfort I sometimes feel when others who I respect are not comfortable with my actions or decisions. Finally, I repeat the mantra, "Other people's opinion of me has nothing to do with me," until I'm at peace.

Gentle reader, my hope is that through the stories I have shared, we are now enlightened elephants who realize our strength is far superior to the flimsy stake our legs are chained to. Free at last to stay or go.

endnotes

1. Alyssa Place, "Yet another hurdle for women at work: Their age," *EBN*, February 24, 2021, https://www.benefitnews.com/news/age-is-another-hurdle-for-women-at-work.

2. Michael Waters, "A Patriarchal Tradition That Just Doesn't Budge," *The Atlantic*, accessed April 18, 2024, https://www.theatlantic.com/family/archive/2021/10/patrilineal-surnames/620507/.

3. Debra Michals, "Lucy Stone," *National Women's History Museum*, 2017, www.womenshistory.org/education-resources/biographies/lucy-stone.

4. Julia C. Lamber, "A Married Woman's Surname: Is Custom Law?" 1973, *Articles by Maurer Faculty*, 969, https://www.repository.law.indiana.edu/facpub/969.

5. Waters, "A Patriarchal Tradition That Just Won't Budge."

6. "Our mission," *Rotary.com*, https://www.rotary.org/en/about-rotary.

7. "Kobe gives wife ring shortly after admitting adultery," *ESPN.com*, July 24, 2003,

8. Albert Einstein, "The monotony and solitude of a quiet life stimulates the creative mind," *BrainyQuote.com*, https://www.brainyquote.com/quotes/albert_einstein_132607.

9. Gloria Steinem, "And as somebody said, 'Everybody with a womb doesn't have to have a child any more than everybody with vocal cords has to be an opera singer,'" *AZ Quotes*, https://www.azquotes.com/quote/786773.

10. Marisa Tomei, "I don't know why women need to have children to be seen as complete human beings," *BrainyQuote.com*, https://www.brainyquote.com/quotes/marisa_tomei_479844.

acknowledgments

A sketch of this book was on my vision board for years. Without the encouragement and support of many people, the book would not have been birthed.

Thank you to my parents who gave me life, security, and the poster in the hallway of a girl running and above her sat the quote "I believe in me."

To my daughters, Maria and Elena, who continually amaze me as they navigate their place in this world, compelled to make a difference.

To my sisters, Anne and Marci, for sharing this life's journey with me. I know I'm never alone.

To Sara Connell and Kandra Albury, who encouraged me to put my story to paper.

To my development editor, Mary Balice Nelligan, who challenged me to dig deeper and write as though no one would read my words.

To my critique pod members of the Writer's Alliance of Gainesville, who read countless chapters and helped make my story clear and concise.

To the women who have come before me who have had the courage to break out of their own boxes.

Lastly, to you, my readers, thank you for reading words I never thought would make their debut. My hope is that, in exchange for your time, my words make you question things you've never questioned and see things in ways you've never seen.

about the author

Betsy Pepine is a serial entrepreneur in real estate, owning a real estate brokerage, property management firm, title company, and real estate school. *The Wall Street Journal* has consistently recognized her real estate team as one of the top producing in the United States. Betsy's brokerage, Pepine Realty, has been named as an *Inc.* 5000 Fastest Growing Private Company in the USA multiple times and has earned spots on the Top 50 Florida Companies to Watch and Florida Trend Best Companies to Work For lists.

Betsy is endorsed by her mentor, real estate mogul, and *Shark Tank* shark Barbara Corcoran, as well as leading media personalities Dave Ramsey and Glenn Beck.

Passionate about helping at-risk families with children, Betsy founded Pepine Gives, a 501(c)(3) non-profit foundation that helps families facing housing insecurity. Pepine Gives has partnered with Habitat for Humanity to build homes for cost-burdened families. Betsy is also a board member for several for-profit and non-profit companies.

Betsy earned an economics degree from Duke University and an MBA from The Wharton School of Business at the University of Pennsylvania. Born in Philadelphia, Betsy now resides in Florida with her family. Visit her at BetsyPepine.com.

CONNECT WITH BETSY

Follow her on your favorite social media platforms today.

BetsyPepine.com

DON'T MISS THE AUDIO EDITION OF

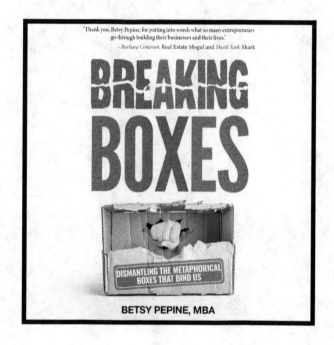

AVAILABLE NOW!

Access additional content and resources by
scanning the QR code below.

THIS BOOK IS PROTECTED INTELLECTUAL PROPERTY

The author of this book values Intellectual Property. The book you just read is protected by Easy IP®, a proprietary process, which integrates blockchain technology giving Intellectual Property "Global Protection." By creating a "Time-Stamped" smart contract that can never be tampered with or changed, we establish "First Use" that tracks back to the author.

Easy IP® functions much like a Pre-Patent™ since it provides an immutable "First Use" of the Intellectual Property. This is achieved through our proprietary process of leveraging blockchain technology and smart contracts. As a result, proving "First Use" is simple through a global and verifiable smart contract. By protecting intellectual property with blockchain technology and smart contracts, we establish a "First to File" event.

Protected By Easy IP®

LEARN MORE AT EASYIP.TODAY

Printed in the USA
CPSIA information can be obtained
at www.ICGtesting.com
LVHW012032140924
790812LV00003B/3/J